IMAGES
of America
SALINE

D0886327

16

WELL, here I am in

Saline, Michigan

Enjoying its sights and cheer,
I'm feeling first rate and this Town is
just great.
Now don't you wish you were here?

IMAGES
of America

SALINE

Susan Kosky

ARCADIA

Published by Arcadia Publishing,
an imprint of Tempus Publishing, Inc.
Charleston SC, Chicago, Portsmouth NH,
San Francisco

Printed in Great Britain.

Library of Congress Catalog Card Number: 2003109643.

For all general information contact Arcadia Publishing at:
Telephone 843-853-2070
Fax 843-853-0044
E-Mail sales@arcadiapublishing.com
For customer service and orders:
Toll-Free 1-888-313-2665

Visit us on the internet at http://www.arcadiapublishing.com

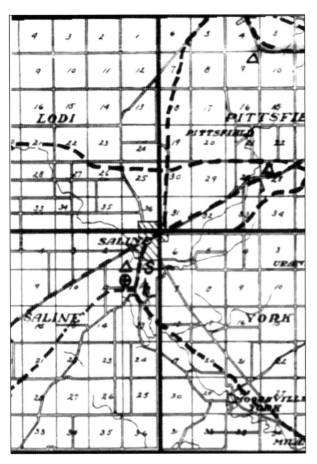

On this map taken from W.B. Hinsdale's 1927 book, *The Indians of Washtenaw County*, broken lines represent the six Native American trails that passed through the townships of Lodi, Pittsfield, York, and Saline. The broken line from section 13 in Pittsfield Township going southwest to section 19 in Saline Township is the Sauk Trail, which eventually became the Detroit to Chicago Road. The line crossing York Township is the trail to Monroe, Toledo, and Sandusky Bay. Just south of the current City of Saline (now Macon Road), salt springs and remnants of a Native American village or campsite were found. The salt "licks" attracted wild animals, making the area good for hunting. During the time of Native American occupancy, the Saline River was navigable to canoes, thus making Saline one of the important Native American centers of the county.

CONTENTS

ACKNOWLEDGMENTS

Several people have my gratitude for their help in compiling information for this book. Without the extensive historical photograph collection of the Saline Area Historical Society, creating this book would not have been possible. The society, particularly Wayne Clements, Agnes Dikeman, Mary Lironis, and Bob Lane. were very supportive. John Farmer shared maps and research material. Pauline Walters at the Washtenaw County Historical Society kindly allowed me to use photographs from the Judge Ross Campbell collection. The Bentley Historical Library at the University of Michigan was a wonderful source of information. Many thanks to the staff for their help, and for allowing me to copy photographs from the Sam Sturgis Collection. While no photographs were used from the Henry Ford Museum, the staff brought out numerous boxes of information and copied several articles for me. The staff at the Saline Library was, as always, willing to help. Kathie Glynn, my friend and business partner, co-authored an historical and architectural survey of Saline with me in 1993, and from that I culled some of my research material. My friend, Gladys Saborio, took on the difficult task of editing, for which I shall be forever grateful. Maura Brown, my editor, encouraged me when I needed it most. My husband, Tom, was a constant source of support and a wonderful cook.

Photo Credits:

Page 2: Washtenaw County Historical Society, Judge Ross Campbell Collection.
Page 4: Map from *The Indians of Washtenaw County* by W. B. Hinsdale
Chapter One: Map of Washtenaw County, Michigan by Bechler, Wenig & Co. (1856 Saline map reproduced with permission from the Genealogical Society of Washtenaw County, Michigan), the Washtenaw County Historical Society, Judge Ross Campbell Collection, the Saline Area Historical Society, and the author's collection.
Chapter Two: Saline Area Historical Society and Bentley Historical Library, Sam Sturgis Collection.
Chapter Three: Saline Area Historical Society and Bentley Historical Library, Sam Sturgis Collection. Map of Washtenaw County, Michigan by Bechler, Wenig & Co. (1864 Saline map reproduced with permission from the Genealogical Society of Washtenaw County, Michigan)
Chapter Four: Saline Area Historical Society.
Chapter Five: Saline Area Historical Society and Washtenaw County Historical Society, Judge Ross Campbell Collection.
Chapter Six: Saline Area Historical Society.
Chapter Seven: Saline Area Historical Society and Bentley Historical Library, Sam Sturgis Collection.

INTRODUCTION

Saline in the twenty-first century is a growing community. As in the nineteenth and twentieth centuries, new families are continually moving into the area, bringing their cultures and histories with them. Hopefully this book will introduce them to the "Saline that was"—and for the old timers, will be a source of fond memories.

The Saline River was named by early French fur traders and explorers who derived its name from salt reserves found in the area. Before pioneer settlement in the 1820s, the French, Native Americans, and many animals were attracted to the region because of the salt. In 1817, the Saline area was one of six sections of land conveyed to the University of Michigan, still in Detroit, by Chippewa, Ottawa, and Potawatomi Indians as a potential site for educational benefits for Native American children. The Saline site was eventually rejected, and a salt spring along the Rouge River chosen instead. Salt reserves have been documented on two known area sites: 8784 Saline-Macon Road, once the Ruckman-Finch farm, and 550 S. Ann Arbor, once the home of A.W. Barr.

Mr. Barr found Native American artifacts on his property, however the location of burial grounds or a village has never been found. Canoes could come to Saline from Lake Erie on the Saline and Raisin Rivers, so it is possible that Native Americans camped here, but did not establish a village. In a piece from the *1886 Michigan Pioneer and Historical Collection*, F.A. Dewey recounts his 1829 travels through the Saline area, noting the salt springs and the remains of a military barracks from 1814 used by General Harrison's army to defend the area from Indian attack. Orange Risdon, the man who surveyed the Detroit to Chicago Road (now US-12), also documented Native American villages on his 1825 survey map. The closest to Saline at that time was in the Macon area. In fact, the Detroit to Chicago route that Risdon surveyed as a military road was the Great Sauk Trail, one of six Native American trails in the Saline area.

Risdon came to Michigan in 1823 and apparently liked the Saline area enough to eventually make it his home. Although Leonard Miller is credited with building the first log cabin in the area on the Saline River near the salt springs in 1826, Orange Risdon is celebrated as the founder of Saline.

Returning to the area in 1824, Risdon purchased 160 acres of land in Section 1 of Saline Township. In addition to building a house in 1829 on the west end of his property, much of Risdon's land was eventually donated for various buildings. North-south roads to Ann Arbor, Tecumseh, and Monroe crossed the Chicago Road, making it an ideal site for settlement. Platted by Risdon in 1832 to be six city blocks with the Chicago Road as its main street, the

hamlet was officially called Saline, named after the river running through it.

Settlement in Saline took place from approximately the 1820s to the 1850s. Pioneers came primarily from the eastern states, many by way of the Erie Canal, which was completed in 1825. Access to the area using Native American trails and the Saline River encouraged settlement. Homes, churches, and businesses gradually formed the community of Saline. In 1848, Haywood's addition stretched the hamlet to the west. The surrounding townships of Lodi, Pittsfield, York, and Saline gradually became a patchwork of farmsteads, cultivated fields, and woods. Country schools began to dot the area. During this period farmers engaged in subsistence farming, growing and making what each family needed to survive, and sharing or bartering with neighbors if there was an excess in production.

In 1866, contiguous portions of Lodi, Pittsfield, York, and Saline Townships incorporated to form the Village of Saline. Two things happened in the second half of the nineteenth century that influenced the lives of Salinians. One was the industrial revolution in the United States and its innovative tools, which enabled people to create new styles in architecture, build new businesses, and survive life on the farm a bit easier. Agriculture evolved into a business rather than just a means of survival. The second occurrence was the arrival of the railroad in 1870, which opened up a new world to the people of Saline and brought new products and potential to the area. Much growth took place. New homes were built in the popular Gothic, Italianate, Second Empire, and Queen Anne styles, the first Union School was constructed, the interurban arrived, and new businesses—many related to farming—were established, making Saline a principal agricultural shipping point. A.H. Risdon's Addition to the east, Bennett's Addition near the railroad tracks, and Mill's Addition near the original town were platted soon after the arrival of the railroad. The influence of German immigrants was seen in schools, a German park on Bennett Street, social organizations, churches, and banking.

New modes of transportation produced change in the first half of the twentieth century. The interurban, in business until 1925, went to Ypsilanti and points beyond. New businesses such as gas stations, garages, and tourist cabins sprung up as a result of the paving of the Chicago Road (US-12) in 1925 and the availability of motorized vehicles. New homes in the Colonial Revival and Craftsman style were built. Perhaps because of the agriculture-based economy, Saline made it through the Depression intact. Both Saline Valley Farms and the Ford Village Industry in Saline contributed to the economy during this difficult time. In 1931, the village became a city.

The photographs used in this history of Saline were taken from approximately 1850 through 1950. I included a chapter on settlement because even though photography was not in wide use until the mid-nineteenth century, enough photographs exist to document Saline buildings and people from that earlier period. Though it has been argued that photography can be biased, it still remains an excellent tool for documentation.

Early accounts of the Saline area note the beautiful scenery, good soil, and access to the Saline River. Saline was, and still is, a good place to call home.

One

SETTLEMENT FROM THE
1820S TO 1850

Land purchased by Orange Risdon became the site of the original hamlet of Saline, which he surveyed and platted in 1832. The community was three blocks north and three blocks south of the Chicago Road (now Michigan Avenue). Adrian Street (now S. Ann Arbor Street) and N. Ann Arbor Street formed a north-south intersection. Risdon recorded the plat in 1838.

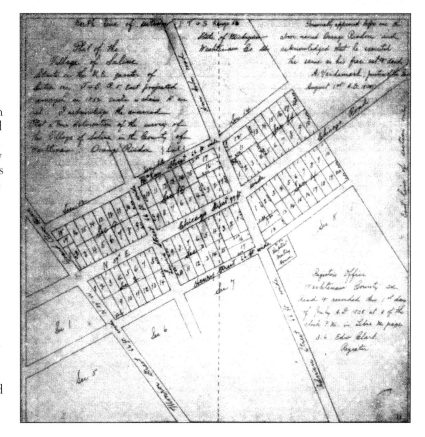

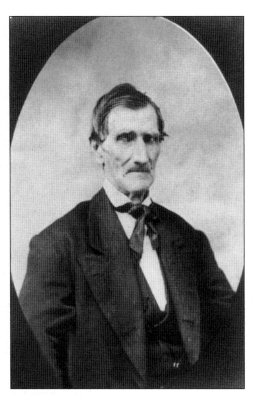

Orange Risdon (1786–1876) was born in Rupert, Vermont on December 28, 1786. As a young man he studied navigation and surveying. He then worked as a surveyor, assessor, and as a navigator on a Great Lakes ship. Congress, on a motion by Father Gabriel Richard in 1824, voted $3,000 for the survey of the Detroit to Chicago Road. Orange Risdon was hired to do the surveying. The survey of the road, now US-12, along with the opening of the Erie Canal in 1825, provided better access to areas of Michigan that were eventually to be settled.

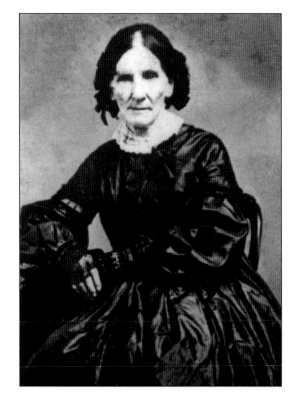

Sally Newland Risdon, from Wilton, New York, married Orange Risdon in Stillwater, New York in October 1817. They were the parents of six children by the time they finally settled in Saline in 1829. Sally and Orange Risdon built a silkworm factory at 111 N. Ann Arbor Street; the building was demolished in 1957.

Surveyor Orange Risdon passed through the Saline area in 1823, and in 1824, was among the first to obtain property in Saline Township, much of which he eventually donated for schools, churches, and the Oakwood Cemetery. In 1829, he built this Federal style clapboard house for his wife, Sally, and six children. The house, in addition to sheltering the family, was used as a post office, an inn, a store, and was the location of the first Saline Township meeting. It was also rumored that the house sheltered slaves traveling on the Underground Railroad. Mr. Risdon lived in his home until the age of 90. Originally located on a hill that is now part of Oakwood Cemetery, it has since been moved to 210 W. Henry Street.

Orange Risdon purchased the land for this house at 101 N. Lewis from the United States government on April 5, 1825. Family history indicates that Risdon lived in this house until his wife and family came to Michigan a few years later.

Orange Risdon built this livery barn behind the house at 101 N. Lewis. Its location near the Chicago Road made it handy for commuters to stable their horses and for horse-drawn sleighs and wagons to be rented to travelers. Moved near the depot in 1990, it is now part of a museum complex operated by the Saline Area Historical Society. Several other extant nineteenth century livery barns are among Saline's architectural treasures.

In 1829, Orrin Parsons constructed the first known house to be built within the current boundaries of Saline Township on the plank Saline-Monroe Road (now Mooreville Road). He also built a sawmill in 1827 (with his brother, Chester), and a gristmill in 1836. A brickyard that made bricks for Saline's early buildings was operated on the farm. Orrin Parsons and his wife were the parents of six children. According to rumor, a secret underground tunnel on the property sheltered slaves traveling on the Underground Railroad.

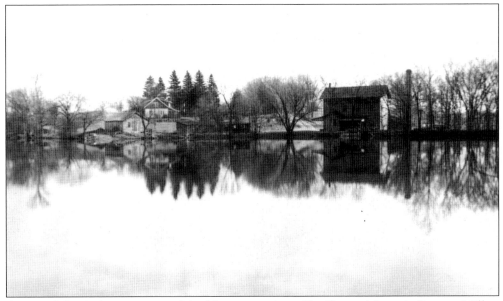

Among Saline's first commercial buildings were its mills. Pictured here is Parsons Mill, a gristmill built by Orrin Parsons in 1836 on Hartman Road. Enlarged in 1842, the mill was later known as the Friis & Minnett or Saline Mills. Fannie Friis operated the mill for more than 40 years and was entered in *Ripley's Believe it or Not* as the country's only female miller.

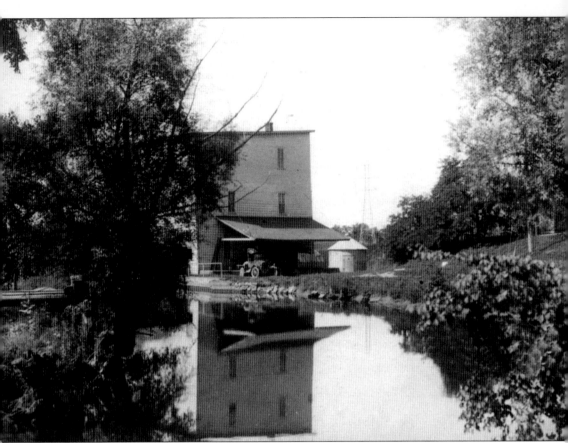

The water-powered York Mill was built in 1836 on the Spring Brook in York Township. In 1868, it was renovated to use either water or steam. The mill burned in 1881, and was rebuilt by J.G. Hoyt & Son. For more than 45 years the mill produced White Swan flour, used in many Michigan kitchens. In 1911, Edward and Herman Alber bought the mill, selling it to Jacob Theurer a few years later. In 1930, ownership of the property reverted to Edward Alber, who again called it York Mill and began producing "Snow Loaf" flour. Alber later sold the mill to Gerhardt Cekau. It ceased grinding grain after World War II. It was razed in 1945 to make way for a new slaughterhouse for poultry.

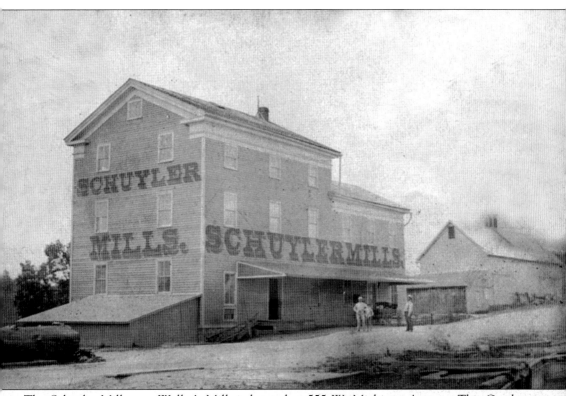

The Schuyler Mill, now Weller's Mill, is located at 555 W. Michigan Avenue. This Greek Revival gristmill was built in 1845 by David Schuyler Haywood west of the hamlet of Saline on the plank Chicago Road near the Saline River. A community known as Barnegat—named for Haywood's hometown of Barnegat, New Jersey—developed around the mill. In addition to homes, businesses such a blacksmith shop, cooper shop, an ashery, a sawmill, a weaving shop, and Charles McKay's combined hardware and tin shop developed around the mill. The once booming settlement of Barnegat deteriorated in the first half of the twentieth century. According to one theory this was due, in part, to a hill being leveled between Barnegat and Saline, making access to Saline easier for consumers. Henry Ford removed most of the old buildings after he purchased the mill and water rights in 1935.

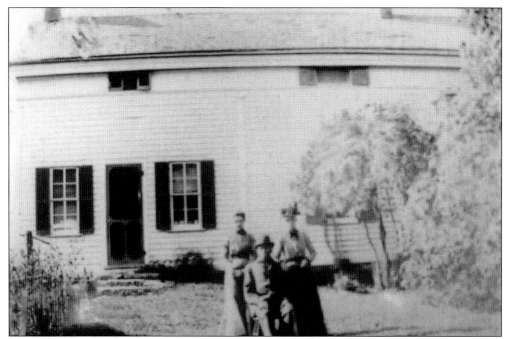

The Ruckman house incorporated the original plank road tollhouse (on the left) located on Macon Road, south of Saline. A tollgate was operated on the bridge until the late 1880s. The 1864 Saline Township plat map shows salt springs on the property. In 1865, a company was formed that unsuccessfully attempted to manufacture salt from the springs. In 1943, Harry Finch, grandson of Eden Ruckman, discovered the old springs on the farm.

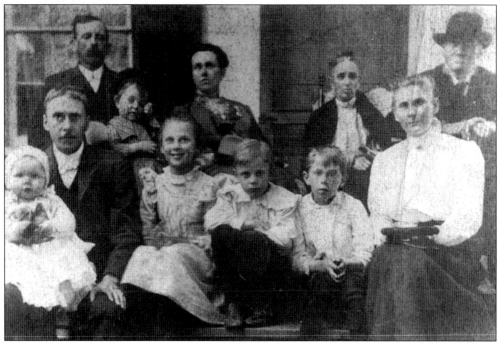

Pictured here is the Ruckman family, date unknown.

The McClue farmhouse is one of several Greek Revival style structures built in the townships surrounding Saline in the first half of the nineteenth century. Pioneers came primarily from New England, New York, and Canada and brought with them the Greek Revival style of architecture, fashionable from 1820 to 1860. Many of these farms, including this one in Saline Township, are still contributing to the agricultural economy.

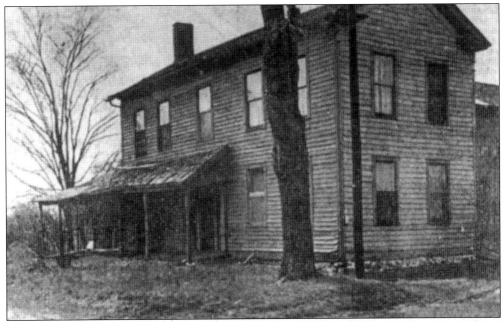

The Halfway Inn was located halfway between Saline and Clinton on the Detroit to Chicago Road across from what is now the Polar Bear Bar. This inn was one of several stagecoach stops along the road, including Alfred Miller's 1834 Exchange Hotel and Leonard Miller's 1826 hotel in Saline.

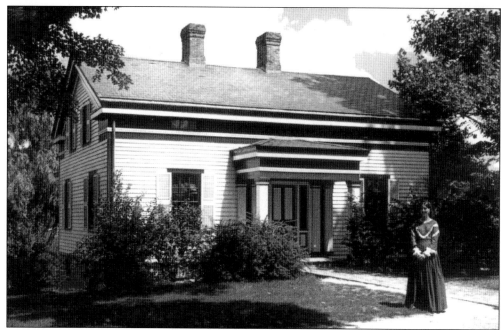

One of Saline's early homes, the Baptist Church parsonage, was built in the Greek Revival style in 1833. George Matthew Adams, a nationally syndicated news columnist and author, was born in the parsonage in 1878. Henry Ford, who enjoyed Adams' column, "Today's Talk," was a close friend of his. Ford purchased the house and moved it to Greenfield Village, in Dearborn, Michigan, in 1937.

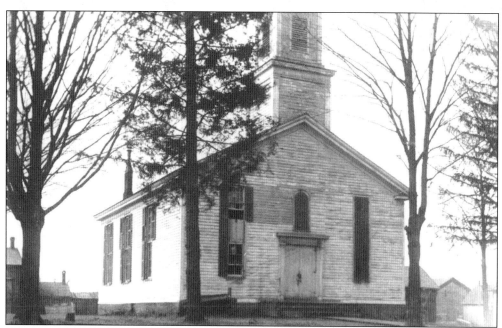

Members of the Baptist Church, one of the first churches to be organized in 1831, first met in the home of Deacon Jesse Stephen. This church building was constructed in 1837 on the corner of E. Henry and Adrian (S. Ann Arbor Street) Streets.

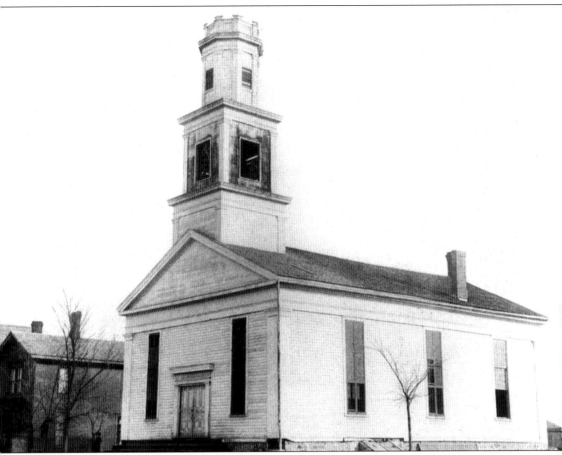

The Methodist Episcopal Church community originally met in area homes and received a visit once a month from the Methodist preacher who stopped in Saline on his 400-mile route called the "Tecumseh circuit." In his diary, Rev. Elijah Pilcher, a circuit rider, said, "At night my greatcoat made my bed, my saddle and my saddle bags my pillow. The wolves howled most hideously most of the night." The first church, built in the early 1830s, was a wood frame building that was struck by lightning in 1836, killing two members of the congregation. An interim "mud church" was used until this New England style wood building was constructed in 1837.

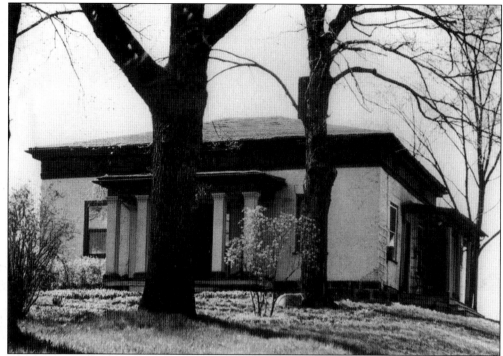

Built *c.* 1833 by John Haywood, this lovely Greek Revival house stood on the north side of the Chicago Road (near the present American Legion Hall), across from Orange and Sally Risdon's home.

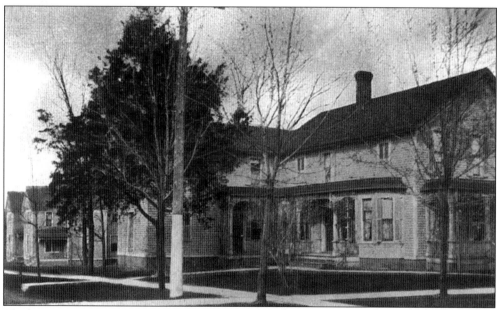

The house at 100 W. McKay Street is known as the "House of Mayors." It was built *c.* 1850 by Joseph Bickford, clerk of Saline Township. Harvey Bennett (a Saline street bears his name) lived in the house in 1869 and was the first mayor to inhabit the house. Other mayors were Gilmer C. Townsend, Hugh Keveling, and Hubert Beach.

The Greek Revival style McKinnon Building was the first commercial building to be erected in Saline. Silas Finch, who had a store from 1829–1831 in the parlor of the home of his sister, Sally Risdon, built it in 1832. The lumber for the structure came from a little sawmill that sat below the dam at the Parsons Mill. The McKinnon Building burned in January 1915.

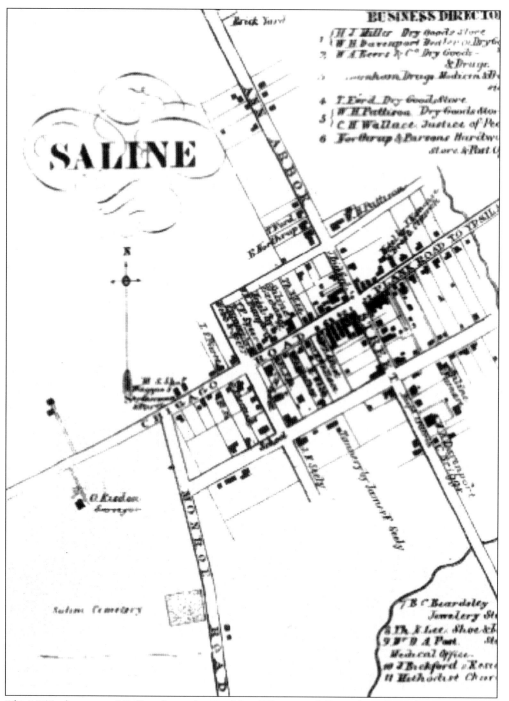

This 1856 plat map of Saline from the Bechler, Wenig and Co. atlas of Washtenaw County helps one to visualize the hamlet as it was in the mid-nineteenth century.

Two
AGRICULTURAL
HERITAGE

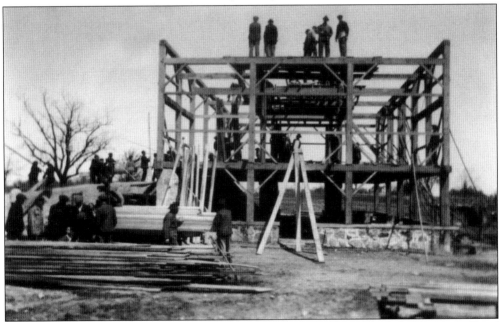

Barn raising was usually a cooperative effort among neighbors. First the foundation, usually of stone, was constructed, and then the main girder had to be put in place. Before the invention of power tools, the beams and pegs were hand hewn. Starting early in the morning, the timber-framed walls were raised and then the workers spread out to accomplish a variety of tasks. Usually the owner did the siding and roofing work with a few helpers. Interruption for a home-cooked meal was always welcome.

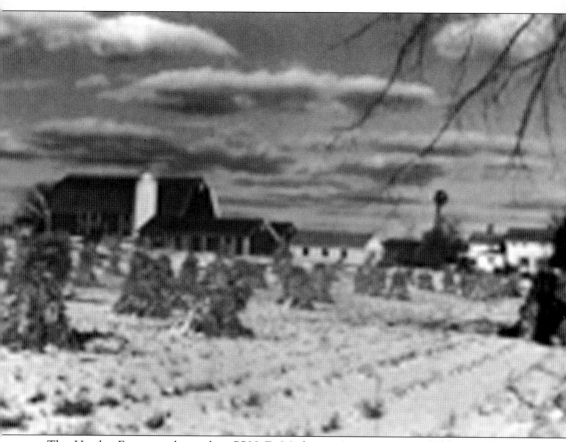

The Hertler Farm was located at 7500 E. Michigan Avenue in Pittsfield Township. The Greek Revival house, built in the first half of the nineteenth century, was purchased from Edgar J. Bickford by Gottlib Hertler in February 1890 for $7,110. In addition to his job as Vice President of the Saline Savings Bank, and raising hay and cattle, Mr. Hertler (the name means shepherd in German) raised sheep. His sons, Alfred, Karl, and John worked the farm after he retired until their deaths.

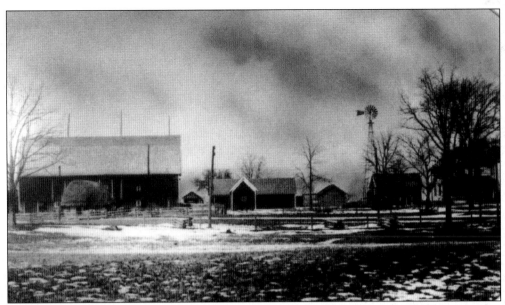

Located on Michigan Avenue east of the main business district, the Rentschler Farm is now a farm museum run by the Saline Area Historical Society. Matthew Rentschler purchased the farm in 1901, and the old farmhouse was replaced with the current Queen Anne style house. The farmhouse and 11 outbuildings show how farm families lived in the twentieth century and how their hard work contributed to the community of Saline.

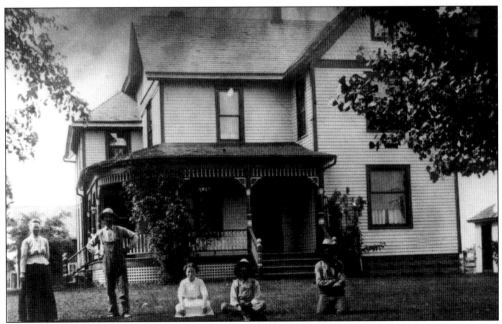

This is a photo of the Matthew Rentschler family in front of their home.

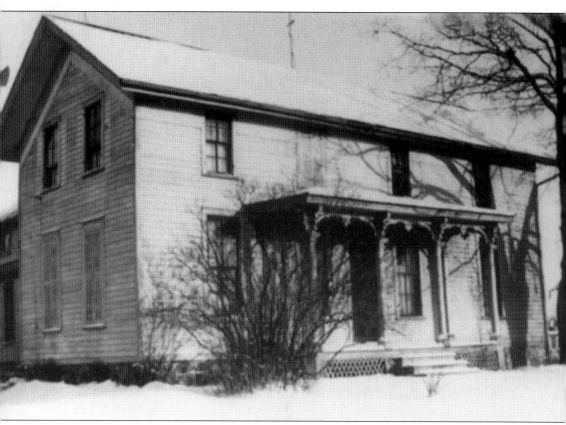

The Morton farm was located at 7876 Michigan Avenue. The farmhouse was built *c.* 1880. James Morton began farming here in 1917 and later his son, Robert, raised poultry here. In 1982 the land was sold and the farmstead replaced with the Saline Shopping Center. All that remains of the farm is a former chicken house, now a real estate establishment.

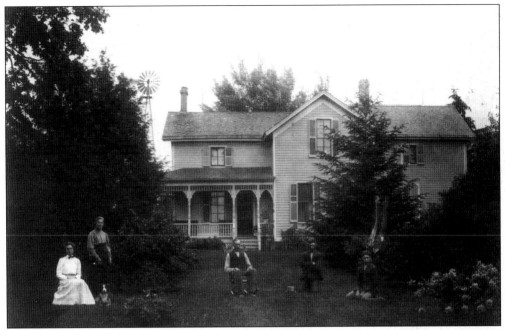

The Clements' farmstead is located in Lodi Township. The Clements family is pictured in front of the farmhouse, most likely built by Thomas Wood c. 1850, and eventually purchased by William Clements in 1886.

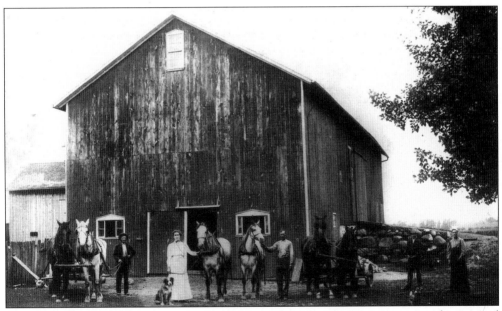

One of the barns on the property is pictured here. William Clements was engaged in general farming and in the 1930s and 1940s he started custom thrashing, silo filling, and corn husking for neighbors. The farm remains in the Clements family today.

Pictured are two Lodi Township farms. On the left is Ed and May Wahr's house on Brassow Road in Lodi Township. On the right is Fred and Leona Stollsteimer's brick farmhouse. Fred and May were brother and sister. Travis Pointe houses now occupy the farm site.

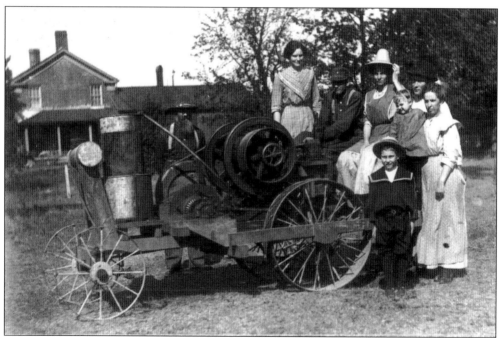

This picture of a homemade tractor was taken on the Stollsteimer Farm in the 1920s.

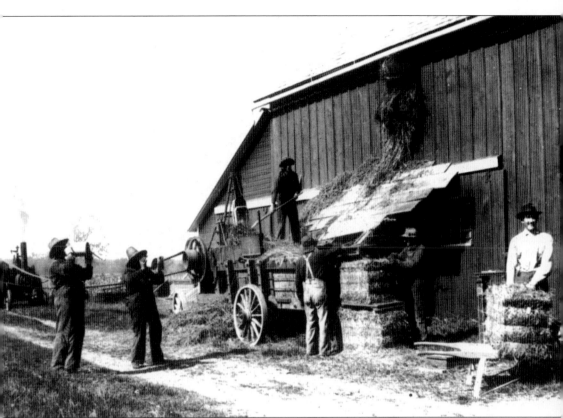

The Brassow family farm was one of many to dot the landscape in Lodi Township. Here workers are shown baling hay with a steam-powered hay baler in the early twentieth century. Many pioneers came to Lodi from Ann Arbor, following markings on a line of trees. In the spring of 1826 a wagon track was cut through from Ann Arbor to Lodi Township. Part of the township was incorporated into the village of Saline in 1866.

This photo was taken during the summer of 1949 at the Harwood farm on Textile Road. William Webb Harwood from Macedona, New York, settled in Woodruff's Grove (now Ypsilanti) in 1824 and built a home for his wife and six children. In 1833, Mr. Harwood traded most of the fifth ward of the present city of Ypsilanti for the entire Section 27 of Pittsfield Township, then owned by John Gilbert. After the transaction was complete in August 1835, he built the farmstead on approximately 200 acres that he divided among his ten living children before his death in 1860. The current house was probably built during the early twentieth century.

Grandchildren, nieces, and nephews were always welcome at the Harwood farm. Pictured are Ralph Harwood, great-grandson of William Webb Harwood, and his nephew, William Plettner from Chicago.

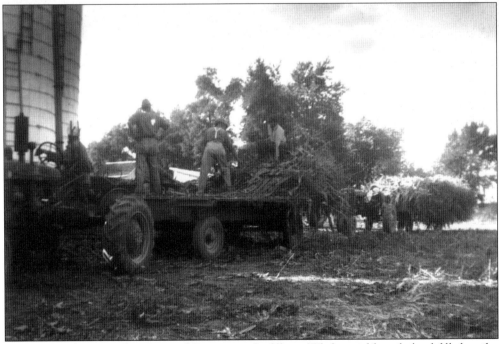

One of the chores at the Harwood Farm was silo filling. While neighbors helped fill the silo, women were busy in the kitchen preparing the noonday meal. The aroma of freshly baked pies filled the summer air.

The Webster Turkey Farm is located just north of the city limits in Pittsfield Township. This stone farmhouse was built in the mid-1800s and remodeled to its present condition in the early 1920s. Noted for its architecture, the farm has also contributed significantly to Saline's agricultural history.

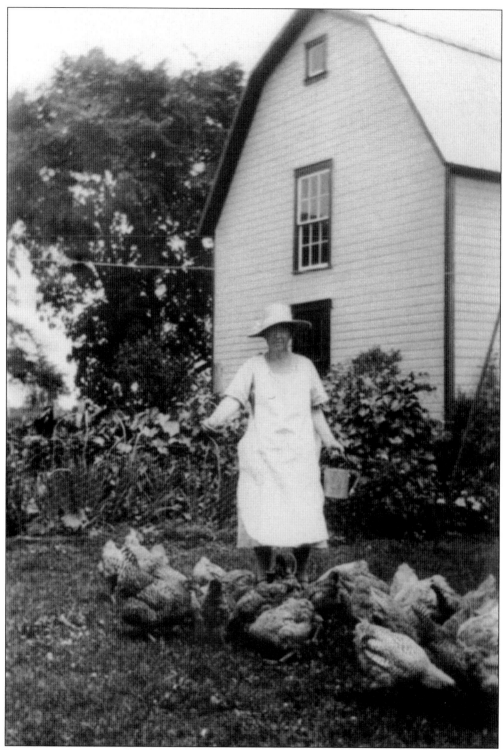

Many area farmsteads and village homes kept poultry. Here an unidentified Saline woman feeds chickens.

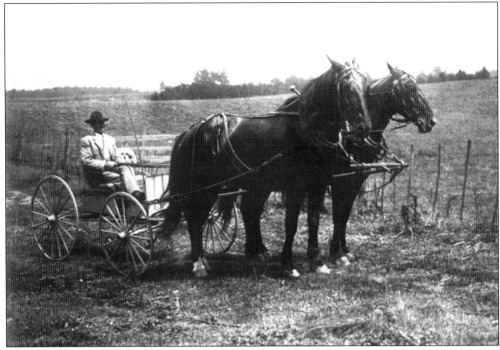

Perhaps this was a leisurely Sunday drive on the LeBaron farm in York Township. The photo was taken around 1918.

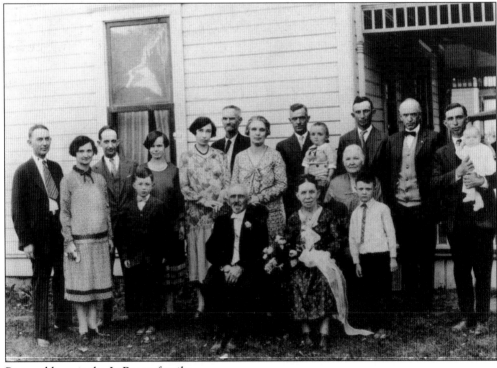

Pictured here is the LeBaron family.

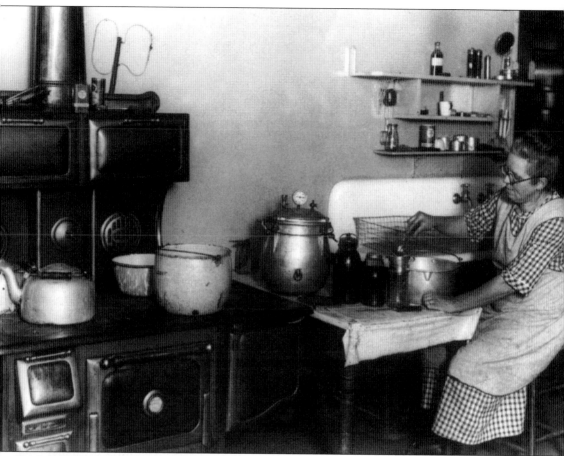

Kitchen gardens were an important part of farm life. Late summer was a busy time in the life of the farmwoman, as produce ripened in the garden. Can you imagine canning fruits and vegetables on a wood stove in August?

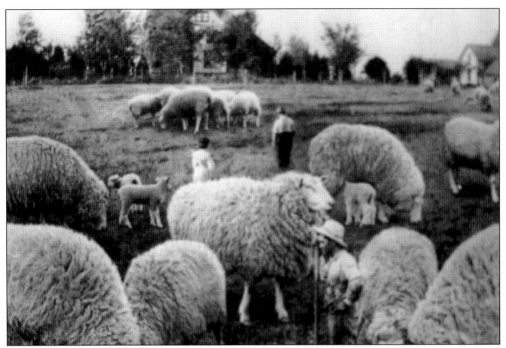

Several local farmers raised sheep in the nineteenth and twentieth centuries, as shown in this 1910 Saline postcard. In fact, Washtenaw County was the leading wool producing county in the state during the late nineteenth century. This was due, in part, to the advent of the railroad in 1870, which facilitated shipping.

Gay Harris and Willis Fowler, who both resided on E. Michigan Avenue, operated a wool warehouse near the depot. It burned in the 1940s.

Three

COMMUNITY:
HOME AND CHURCH

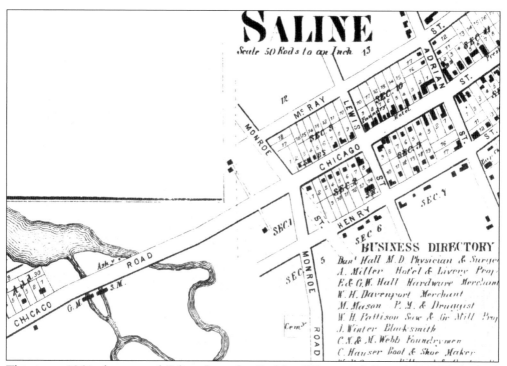

This is an 1864 plat map of Saline from the Bechler, Wenig and Co. atlas of Washtenaw County, Michigan. It shows the 1848 Haywood's Addition, the first formal addition to the hamlet. The community had grown considerably and now had several residences, three churches, and several businesses.

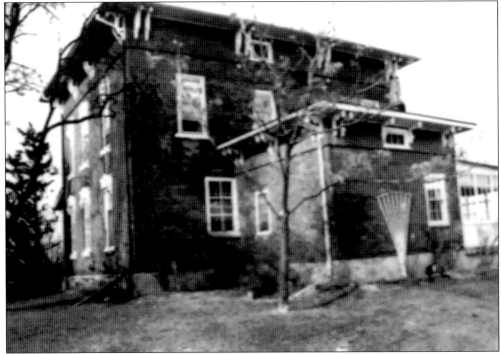

In the second half of the nineteenth century, the Civil War divided the nation. This lovely brick c. 1860 Italianate house on the Chicago Road in Pittsfield Township was rumored to have a secret room that was used to accommodate slaves traveling on the Underground Railroad. The McCoys, active in Music Youth International, occupied it in the second half of the twentieth century.

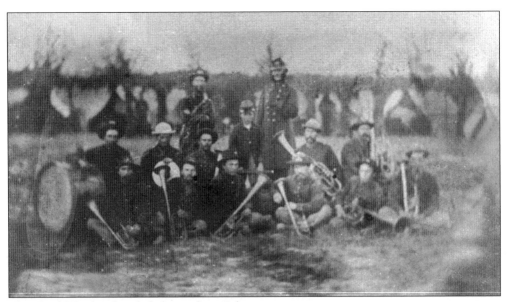

This Civil War band included men from Saline.

John Corden was the commander of the Sixth Michigan Infantry, Company F, known as the "Saline Sharpshooters." Salinians also served in the First, Fourth, Eleventh, Seventeenth, and Twentieth Michigan Infantry, the Third, Fourth, and Ninth Michigan Cavalry, the Christian Commission and Vote Commissioners, and the Stanton Guards.

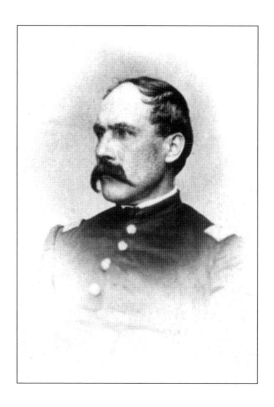

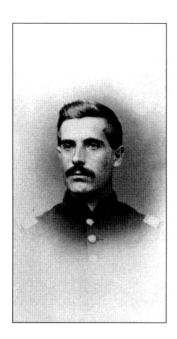

Second Lt. Seymour Howell, pictured here, and Henry Harris of Saline assisted John Corden.

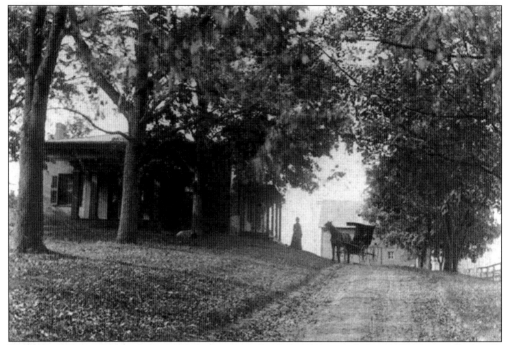

This is a later picture of the 1833 home built by John Haywood. In 1862, the Mills family purchased the property and occupied it until Vesta Mills' death in 1948. Unfortunately the house was left to deteriorate and in 1968 was demolished. Mills Road was named for the family.

Portrayed here is Russell Mills being pulled to town by his faithful horse, Dick, c. 1920. Russell Mills was Vesta Mill's grandfather.

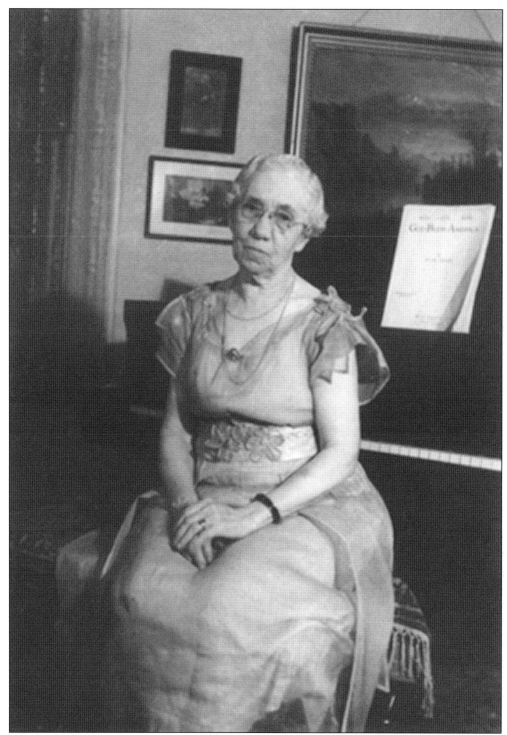

Vesta Mills was a talented piano teacher who was active in community affairs. Miss Mills graduated from the University of Michigan School of Music in 1896. She taught piano from 1893 to 1947.

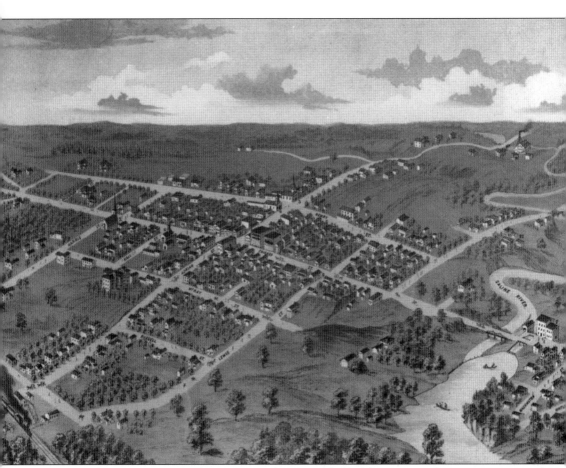

This is a bird's eye view of Saline in 1872. The second half of the nineteenth century saw several changes in the landscape of Saline. The industrial revolution in the United States affected Saline in several ways: new farm equipment made life on the farm somewhat easier, new tools meant changes in architecture, and new inventions simply changed the lives of the population in general. The arrival of the railroad in Saline in 1870 brought even greater change.

This is Maple Street looking north from E. Michigan Avenue. The corner of N. Maple Street and E. Michigan Avenue was known as Fairbanks Corners, named for the Fairbanks family who lived nearby at 315 E. Michigan Avenue in the early twentieth century. Steven T. Fairbanks ran a general store in town.

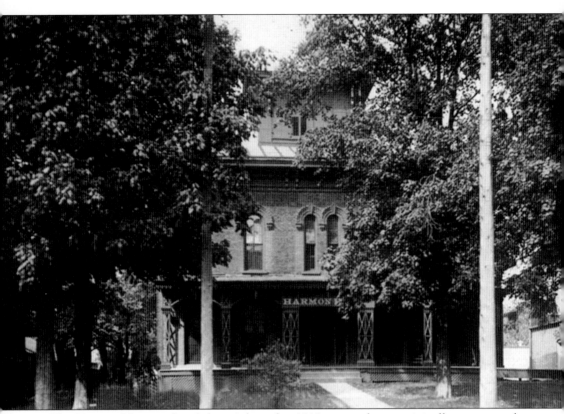

The Harmon House, a hotel depicted on this 1912 postcard, was originally constructed as a home, and was occupied by the William Davenports before they built their home at 300 E. Michigan Avenue.

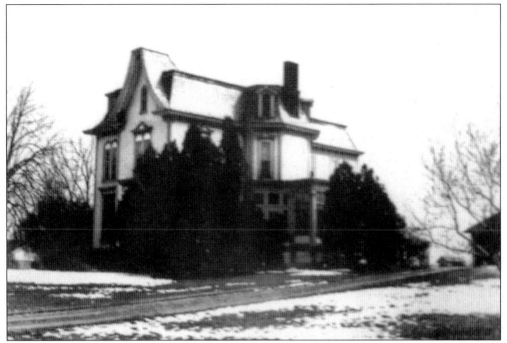

The Beverly and Emily Davenport home on E. Henry Street was built in 1873 for $3,500.

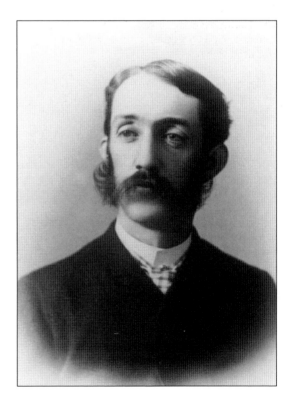

This is a portrait of Beverly Davenport, son of William H. and Zilpha Parsons Davenport. Mr. Davenport was involved in banking with his father.

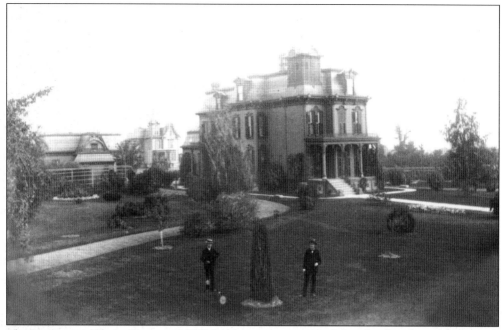

The Davenport-Curtiss House at 300 E. Michigan Avenue is a Saline landmark, and along with the Beverly Davenport House, is a part of the E. Michigan Avenue Historic District. Built in 1876 in the Second Empire style for $8,000, the house and two ornate carriage barns occupy an entire block of fenced, landscaped lawn. In 1932, the Curtis family purchased the house. Mr. Curtis took over as president of the Citizens Bank, following the Davenports.

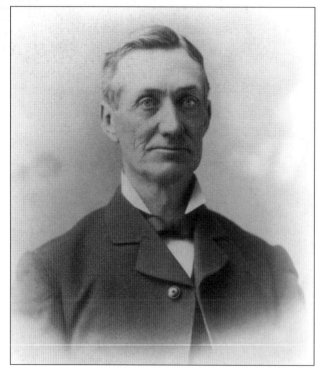

William H. Davenport was a prominent businessman who established the Citizens Bank of Saline. He married Zilpha Parsons, daughter of Mr. and Mrs. Orrin Parsons, also well-known Salinians.

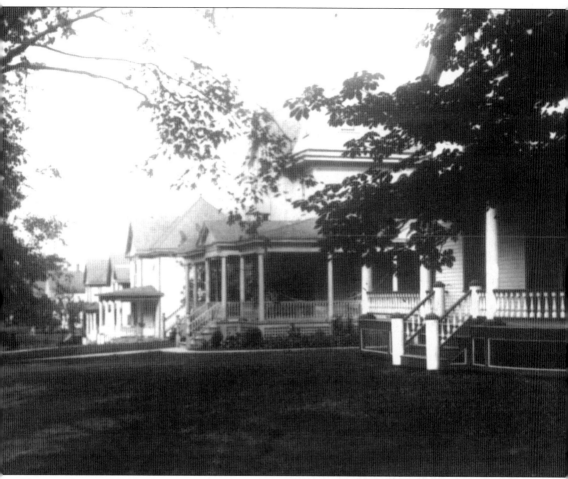

Here is a view of E. Michigan Avenue looking west from N. Maple Street. Homes were built beginning in the 1870s with the platting of the A.H. Risdon Addition. They now comprise the E. Michigan Avenue Historic District.

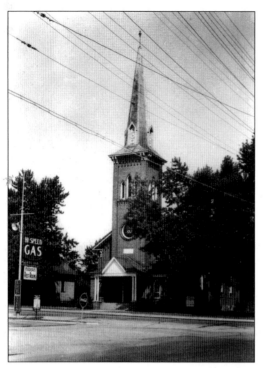

Trinity Lutheran Church at 195 E. Michigan Avenue is one of three Saline churches on the National Register of Historic Places. It was built for $5,600 in 1872, making it the oldest extant church in Saline. Its interesting architecture incorporates elements of both the Gothic and Italianate styles. Many of Saline's prominent German American residents were members of the church community that was formally organized in May 1865.

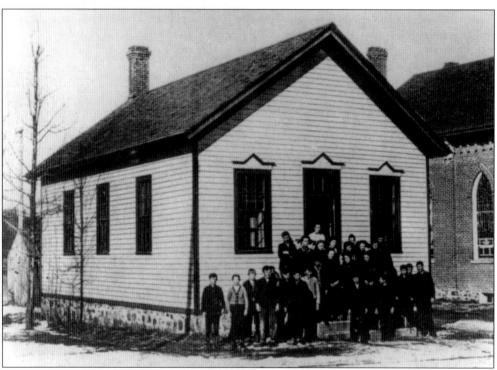

Trinity Lutheran School, located near the church, existed during the first half of the twentieth century. Lessons were taught in German at this school, as well as at the German School near the hamlet of Benton.

Occupied by the Westphal family for 43 years, this house was originally located at 102 N. Ann Arbor Street. The Westphals operated a tavern on Michigan Avenue in the first half of the twentieth century. Before the Westphals, the Fred Heininger and Jacob Sturm families occupied the house. In 1954, it was moved to Spring and Clark Streets to make way for a parking lot.

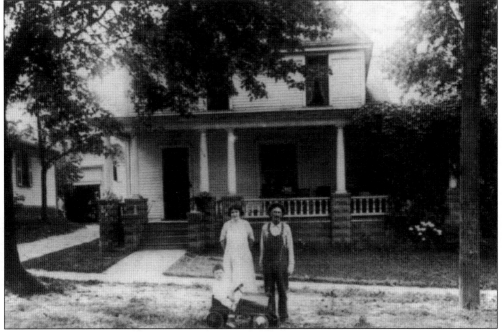

The Alber home on W. Michigan Avenue was next to the current Dodge dealership.

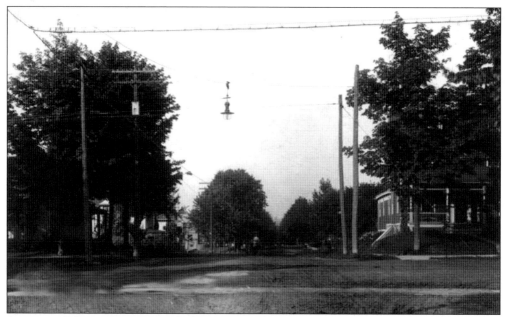

A post card shows Henry Street looking west in the first half of the twentieth century.

John and Katherine Fritz lived at 107 E. Henry Street. Pictured is Mrs. Katherine Fritz at her home, now a parking lot. Mr. Fritz ran a store on Michigan Avenue.

The Weissinger House is located at 102 Russell Street. J. Fredrick Weissinger lived here in the late nineteenth century. Mr. Weissinger was a cabinetmaker who had a furniture and undertaker business at 112 W. Michigan Avenue.

Here is the Henne House at 204 E. Michigan Avenue. Ella Hauser Henne, Fred Henne, and their son, Ed Henne, operated the first phone company. Ella's family, the Hausers, owned the creamery and other businesses in town.

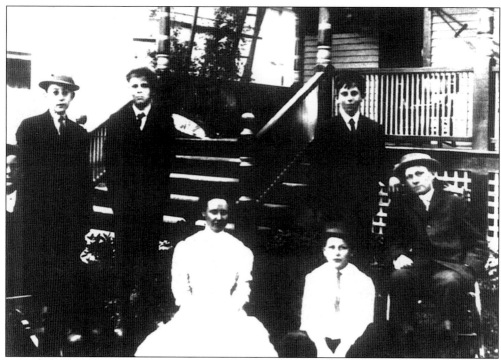

A photograph of the Baptist Church Sunday School was taken *c.* 1901 in front the Julius and Clara Lindenschmitt house at 202 E. Michigan Avenue, now the Harrison home.

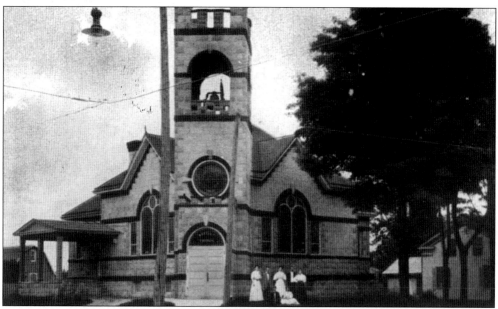

Dated 1913, this post card shows the Baptist Church. In 1905, the Baptists built a church on the southeast corner of N. Ann Arbor Street. The building was eventually used as a hospital, furniture store, funeral home, library, and engineering firm.

Here is the home of John and Catherine Barr and their sons, George and William. In the late nineteenth century, the John Barr and Son Company had a Sorghum, Apple Jelly, and Cider Mill behind their home on Adrian Street (S. Ann Arbor Street). They made cider jelly and shipped it all over the eastern states. According to city directories, John and his son, George, also worked as carpenters, and Will worked as a farmer.

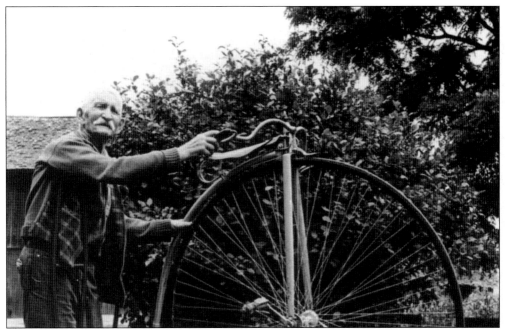

This photograph pictures George Barr in 1950 with the bicycle he rode in his youth. This high wheeler, which preceded the chain-driven bicycle, was a very popular leisure time activity in the late nineteenth century.

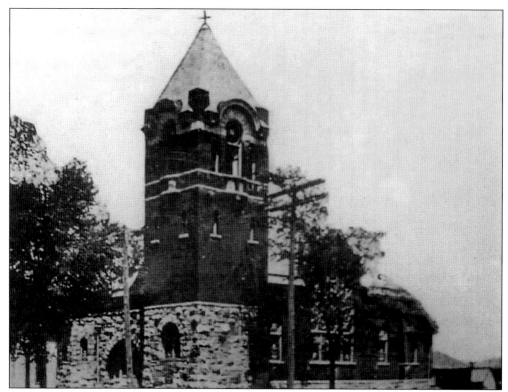

The Methodist Episcopal Church, located on S. Ann Arbor Street, was constructed in 1899. Built of brick and cut stone, it is a handsome example of Victorian Romanesque architecture. It was the fourth Methodist Church building to be erected in Saline.

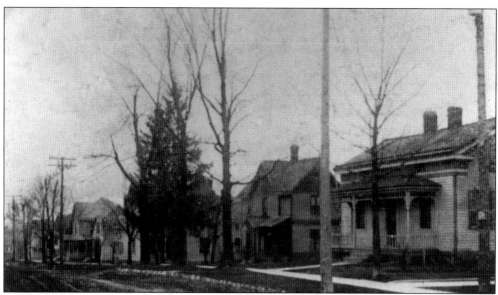

In this 1920s photograph of Adrian Street (now S. Ann Arbor Street), the first house is that of the telephone office, and the second is the home of the Collins family. Bessie Collins (1886–1971) was a Saline historian. Notice that the road was not yet paved.

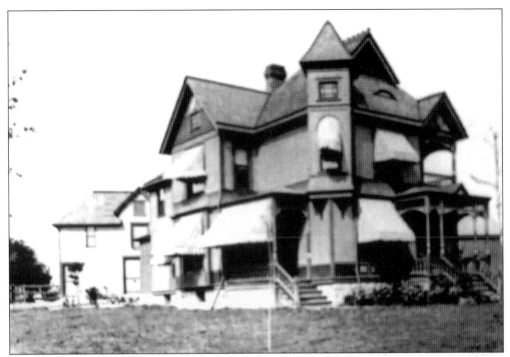

The Harper-Janich House at 319 N. Ann Arbor Street was built in 1876 in a cross gable plan with Queen Anne details. The original owner was State Senator Egbert P. Harper, who represented the Second District of Washtenaw County from 1885 to 1888, first as a Democrat and then as a Fusion candidate. He also served as Lodi Township Supervisor and Justice of the Peace.

The Ford-Lambarth House is at 322 N. Ann Arbor Street. During the latter part of the nineteenth century, the Queen Anne style came into vogue. The 1879 Ford-Lambarth House exemplifies this style with its cross-gabled roof, wrap-around porch, and decorative detailing. Flavius Ford operated the lumberyard at Bennett and N. Ann Arbor Streets

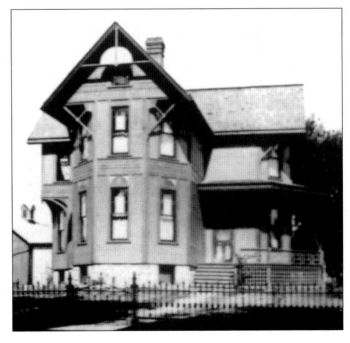

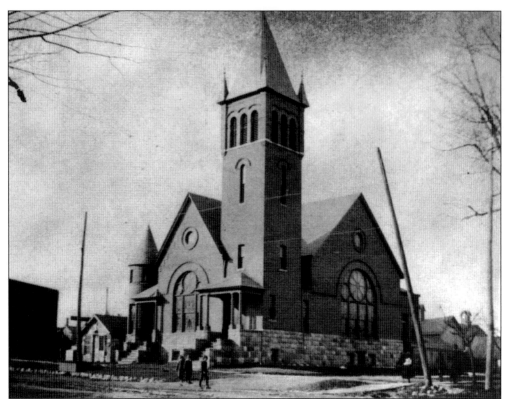

The First Presbyterian Church at 143 E. Michigan Avenue was one of the earliest established churches in the community. The church's 12 original families came from Newark, New York, in May 1831 and met in area homes before building their first frame church in 1842. The current church was built in 1898 in the Romanesque Revival style and was designed by the Detroit firm of William C. Rohns and Frederick H. Spier, who also designed numerous University of Michigan buildings and railroad stations throughout the country.

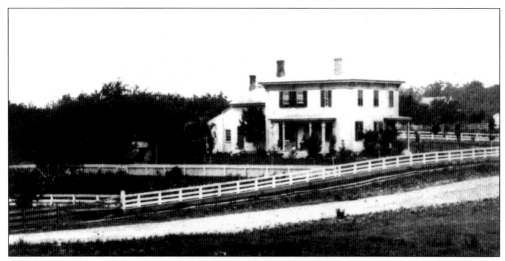

The Presbyterian Parsonage at 307 N. Ann Arbor Street was built in 1861 in the Italianate style. The Presbyterian Church owned it until the 1950s.

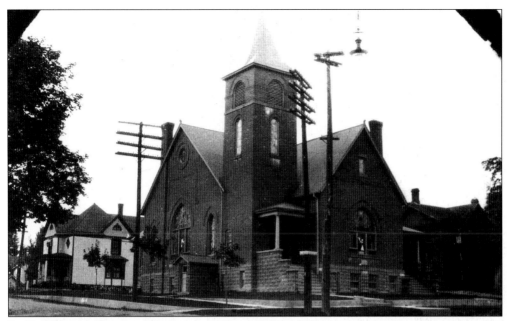

St. Paul United Church of Christ is located at 122 W. Michigan Avenue. The original founders of St. Paul's were members, or descendents of members, of the Evangelical Church in Germany, thus the church was originally called Die Deutsche Evangleische St. Paul's Gemeinde. The new church was formed in 1906, and the present church building was completed in December of 1907. At that time classes were held in both English and German. In 1963, the congregation applied for membership in the United Church of Christ.

From 1920 to 1940 there was significant growth in Saline. In the 1920s and 1930s, the Craftsman style of architecture came into vogue. Saline, not to be behind the times, produced several homes in this style, some of them ordered from catalogs such as Sears. The Lambarth house is a fine example of this style.

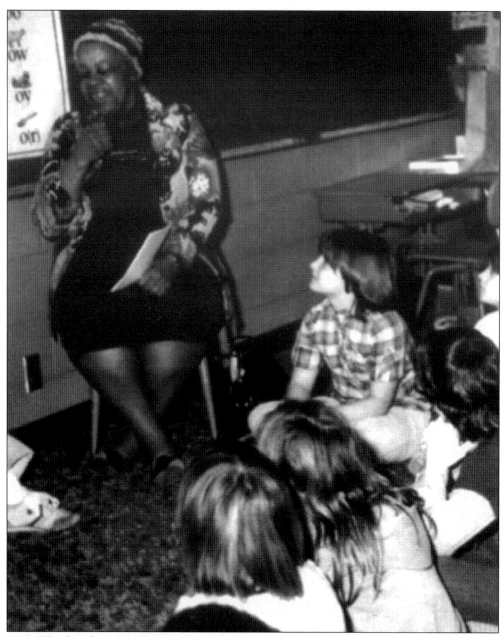

Mary Wood is shown reading to schoolchildren. Her family's heritage is part of the African-American history of Saline. Her grandparents were slaves who traveled to Canada where they gained freedom. They moved to Saline in 1867 with their child, Nancy, who eventually married Henry Morris, a highly respected carpenter. There were ten children from that union. Nancy was honored as Michigan Mother of the Year in 1948. Their daughter, Mary, met Paul Woods in Albion where she went to teach. They married in 1928 and were the parents of eight successful children. The family once lived at 201 Clark Street, the house constructed using some of the beams from an African-American church located at E. Bennett and N. Harris Streets. Another building, the carriage barn at Carl Weidman's home at 210 N. Harris Street, was a meetinghouse of the black community in the 1870s.

Four

EDUCATION

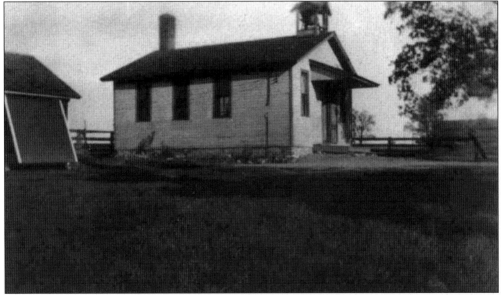

The Wood School, now a residence, is at Weber and Dell Roads. A territorial law was passed in 1827 that required every township with 50 or more residents to employ a schoolmaster with respectable character to teach both academics and moral behavior. Many of the early country schools in Lodi, Pittsfield, Saline, and York Townships were built of logs and then later replaced with frame or masonry buildings. Some of these schools were still being used for education in the 1950s.

Here is an interior photograph of Benton School, located west of town on the north side of Michigan Avenue near Case Road. It was one of many rural schools built in the townships around Saline in the nineteenth century. English, along with other subjects, was the language taught in the Benton School. The school is now used as a farm building.

A class outside the Benton school poses for a photograph. The students lived in or near the hamlet of Benton, which had a post office, blacksmith shop, saw mill, church, dance hall, and two schools. In 1895, a German parochial school associated with St. James Church was located across the road from the Benton School where classes were held part of each day. Many children attended both schools.

Erma Castle, a teacher, and Edward Kuebler are pictured in front of Rentschler School, now a home on the northwest corner of Bethel Church and Alber Roads. Bob Warner, a jealous admirer, shot Ms. Castle to death and was sentenced to five years in jail.

Judd School, now a home on Judd and Saline Milan Roads, was built in 1859 for $429.50. When classes began in 1859 at Judd School, the teacher, Evaline Kelsey, was paid $35 per month. Preceding this school were two log schools, one built in 1836 on Milkey Road and the other in 1847 on Judd Road.

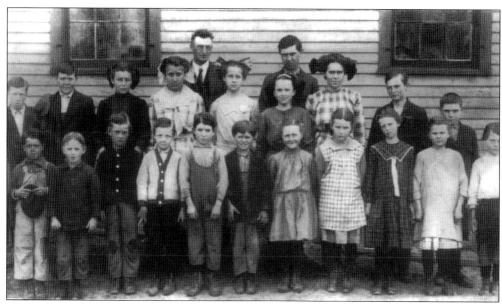

This is one of the classes at Judd School, the date unknown.

The first school in York Township was a log school built in the 1830s near Mooreville, close to the Saline River between Sections 28 and 29. A larger frame building replaced the log school in 1838, and another in 1851. In 1876 the brick schoolhouse pictured here was built on a larger piece of land in the community. In 1879, the district voted that each resident voter plant a tree in the schoolyard.

Located on the corner of Saline-Ann Arbor and Brassow Roads, the Lodi Plains School was built between 1835 and 1845 to replace an 1829 log schoolhouse. It was the heart of a crossroads hamlet and served the community not only as a school, but also as a meeting hall and social gathering place. A tollgate for Saline-Ann Arbor Road was situated near the building.

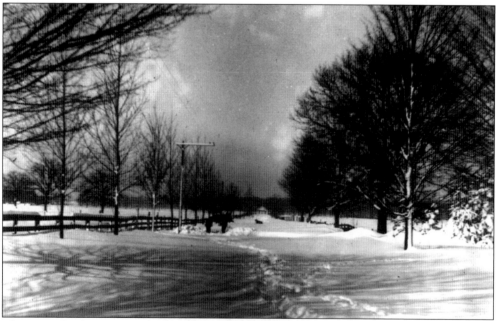

This is Lodi Plains School in winter, looking west down Brassow Road. Remember your grandfather talking about the long walk he had to school when he was a child? Country schools were located so that a child never had more that approximately two miles to walk to school.

The Weber-Blaess School was built in 1868 at Ellsworth and Gensley Roads. A recent archeological survey revealed that the school was built upon the foundation of a previous school. Fire-cracked rock, melted glass, nails, and a charred beam were used to document the demise of the former school by fire. Evidence existed, which showed that a wood burning stove that sat in the middle of the former country school was most likely the cause of the fire. Also found in the survey were hinges, stove parts, a school desk part, slate pencils and tablet, buttons, straight pins, safety pins, ceramic pieces, a plate, a cup, a pocket knife, a key, the stem of a clay pipe, animal bones, window glass, and medicine bottles, one of which was identified as Hamburg Drops, an elixir that was 50% beef extract and 50% alcohol. The building was moved to the Saline Area Schools' property near Woodland Drive, and after restoration, will be used to interpret a day in the life of an old country school.

The Carpenter Country School, on Carpenter Road in Pittsfield Township, predated a larger brick school near Packard where high-rise senior housing is now located.

The Bond-Forbes School was located at 11605 Saline-Macon Road. The Bond School District (Saline No. 4) was organized in 1837. It is unclear why the district was named Bond, as the 1837 log school was built on the property purchased from E. Reynolds, located across the road from 11605 Macon on land contiguous to Samuel Bond's land. Speculation prevailed that the name Bond had something to do with the new black walnut desks that lined the one-room school. In 1858, the present school was built at 11605 Saline-Macon Road, complete with 25 new benches. It was the center of community life in the area. The school closed in 1955 and is now a residence.

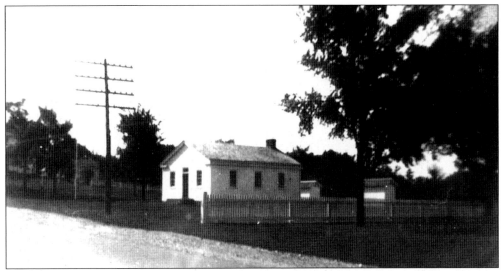

The Hoyt-Sumner School was erected *c.* 1856 on Macon Road in Saline Township, the land being leased by the DePuy and Hoyt families. The Hoyt-Sumner School District included all of Section 12 and parts of Sections 11, 13, and 14. It closed in 1917, and the area children went to school in the city of Saline. The school was used occasionally as a public meetinghouse, until 1943 when it was purchased by Henry Ford and reconstructed on its present location, 600 W. Michigan Avenue, as part of Ford's Village Industry.

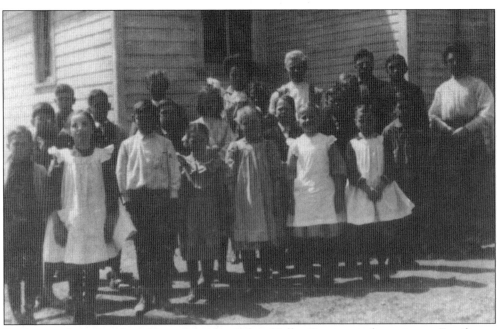

Students and teachers from Howe School at Saline Valley Farms pose for a picture. Families at Saline Valley Farms were part of a communal farm south of Saline in the 1930s and 1940s.

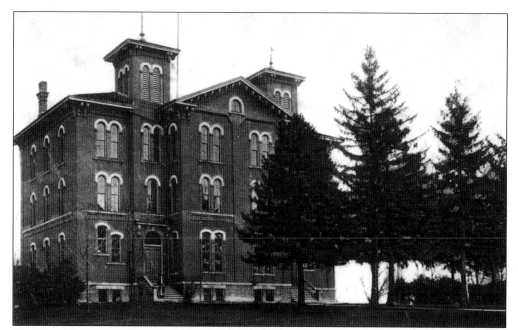

The first school in the hamlet was a one-room frame building that stood on Adrian Street (now S. Ann Arbor Street where the Calico Cat Gift Shop stands). The second was a brick common school built in 1855 on Adrian and Henry Streets. Replacing the common school was the Italianate brick Union School, pictured here, that was built on N. Ann Arbor Street in 1868. It had classrooms on the first and second floors plus two laboratories for chemistry and one for physics. The third floor housed an auditorium and music room. Oil lighting was used until 1907 when electricity was installed. Outhouses were used until sewer lines were put in between 1912 and 1916.

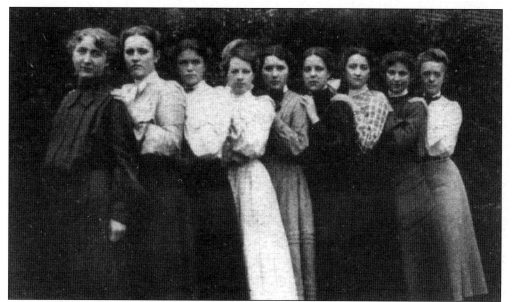

Union School students from the class of 1906 are pictured, from left to right, as follows: Maud Miller, Jenny Webb, Ethel Sweet, Eva Sellen, Luella Nissly, Ermine O'Hara, Genivieve Barr, and Ella Clark.

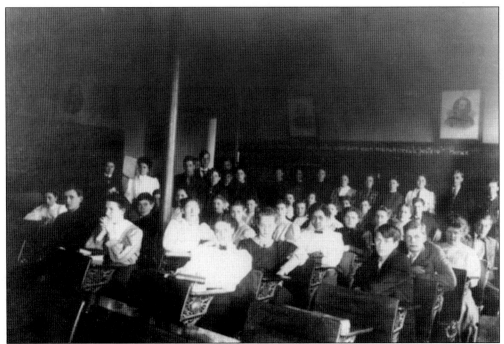

Students from the class of 1908 pose for this interior school picture. Union High School offered high school classes in Saline for the first time, allowing many of the students from the country schools to finish their last four years in town. Transportation was the responsibility of the student's family, so some students came to school in a horse and buggy, which they left in a barn on McKay Street while they were in class.

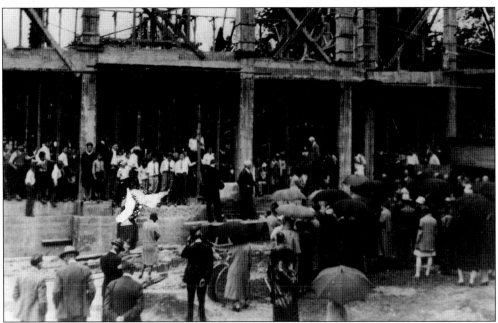

This 1930 photo shows the construction and cornerstone ceremony of the new (second) high school on N. Ann Arbor Street. The building was completed in 1931.

William Austin and Charles Miller prepare the lawn of the new Union School for landscaping in 1931.

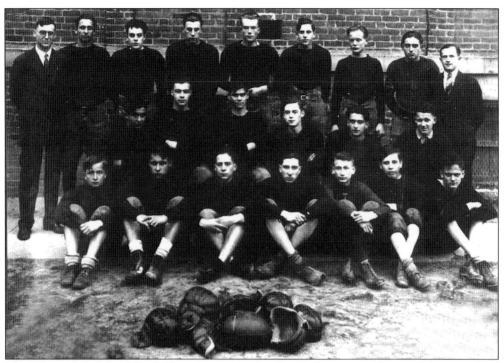

The Saline High School football team is pictured in front of the second Union School, built in 1931 on N. Ann Arbor Street.

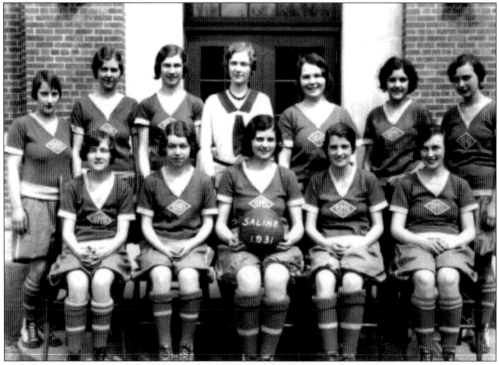

The Saline High School girls' basketball team poses for a picture in 1931.

Five

GROWTH IN THE
TWENTIETH CENTURY

Jacob Sturm's Harness Shop was situated across Michigan Avenue from *The Reporter*, where a city parking lot is now located. Jacob's brother, Louis, arrived from Germany *c.* 1860 to join the business making harnesses and carriages. The house that Jacob Sturm lived in at 102 N. Ann Arbor Street was moved to the southeast corner of Spring and Clark Streets in 1954. Louis Sturm lived at 100 Russell. Between the buildings occupied by Jacob Sturm and LeBaron & Nissley was the "fire department"—a little shed that held two or three-dozen buckets for water. A large cistern was built on Ann Arbor Street, but was only useful if the pump was in working order, and the key could be found. The fire on May 26, 1881 that leveled 22 buildings to the ground prompted the village to look into better fire protection.

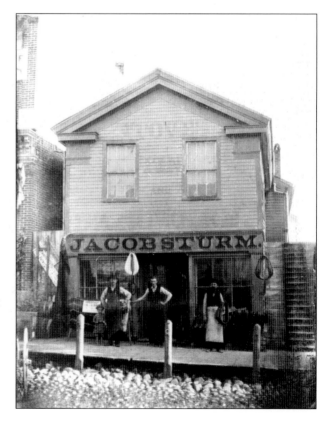

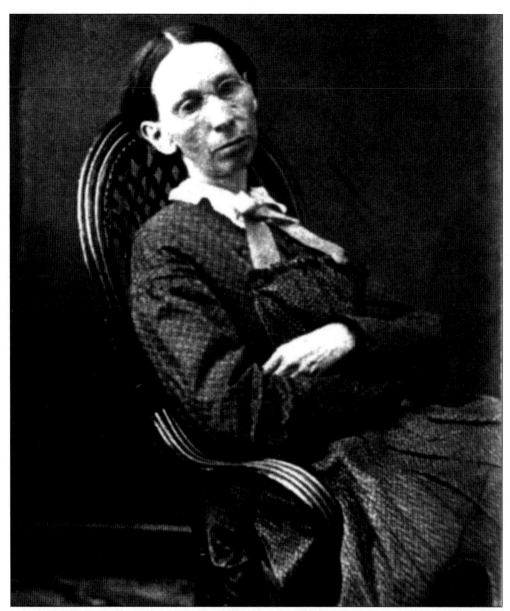

Lucretia Gillett's portrait was done in 1868. Lucretia (b. 1820) moved to Saline from Ogle County, Illinois, with her father and mother in 1858. By 1860, she was listed in the Census for Washtenaw County as one of three daguerrean artists (photographers) working in Saline, Michigan. The others were Susan Hulten and Lucretia's relative, Mr. G.C. Gillett. However, by 1863, Lucretia was Saline's only commercial photographer. She lived with her family and managed her photographic studio at 203 Adrian Street (S. Ann Arbor Street) where she took family portraits and documentary photographs. By 1867, she had changed over from daguerreotypes to the newer wet plate process, which allowed her to make the less expensive, reproducible paper prints. After nearly 30 years as Saline's premier photographer, Lucretia sold her photographic business to the Ypsilanti photographer George Waterman, who advertised his new business as "Miss Gillett's Old Stand." It is thought that at 70 years of age, shortly after she sold her business to Waterman, Gillett moved to Long Beach, California with her two younger sisters.

This is an advertisement for Lucretia Gillett's business. Lucretia's ad states that she was able to create color pictures by using oil, watercolors, and pastels.

The Citizens Bank was located at 100 W. Michigan Avenue. Built c. 1865 by William Davenport as a store, its safe was frequently used by the community. In 1885, Davenport formed a bank there. Carl Curtis, hired by Davenport in 1909, took over as president of the bank after the death of William Davenport's son, Beverly, in 1930. This photo appears to have been taken in the early twentieth century.

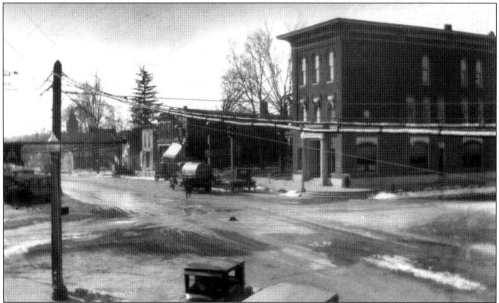

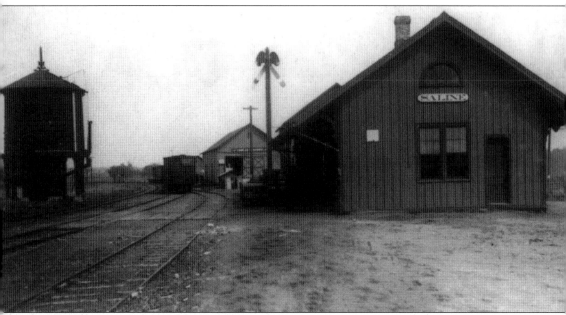

The Detroit, Hillsdale, and Indiana Railroad came to Saline in 1870. Built in 1870 with the arrival of the railroad, the Saline Depot on N. Ann Arbor Street became a necessary component in the daily life of many area merchants, farmers, and citizens. The railroad provided passenger and freight service, opening up the small village of Saline to a larger world. Products such as livestock, grain, wool, silk, fruit, and perishable goods, such as milk and eggs from area farms were shipped to other localities from the Saline Depot. Saline was reported to be the largest rail-shipping center in southern Michigan in 1875. After the Detroit, Hillsdale, and Indiana Railroad went bankrupt in 1875, the line was sold to the Detroit, Hillsdale, and South Western Railroad. In 1881, they leased the line in perpetuity to the Lake Shore and Michigan Southern Railway, part of a group who owned the New York Central. The lease was assumed by New York Central in 1914 and then in 1960 was acquired by the Michigan Central. In 1961, the railroad was dissolved and the Depot closed. The advent of the interurban, automobiles, and trucks influenced the decline of the railroad.

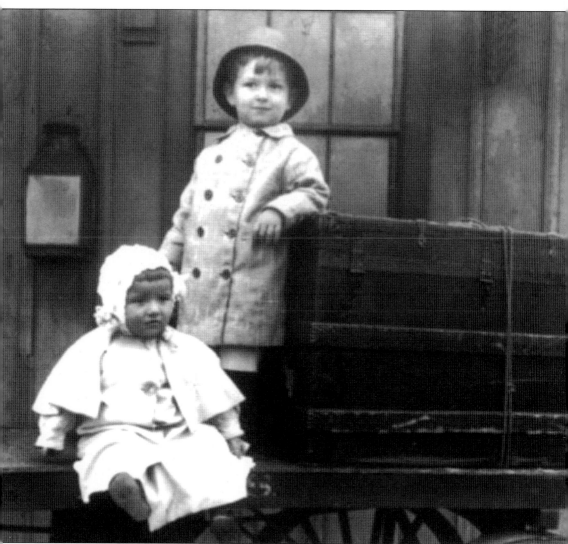

Perhaps these children, their names unknown, are about to begin a new adventure. The depot became important to Salinians not only for commercial purposes, but for its passenger service and telegraph office. It had a passenger waiting room that was heated by a big wood stove. The original waiting room burned in the 1930s and was repaired by adding an exterior wall to the interior wall, thus separating the waiting room from the office. A wooden water tower, stockyards, and a wool barn were located near the depot. After the depot closed in 1961, it housed other businesses. It was given to the Saline Historic District Commission by the Zahn family in 1980, and eventually was restored as a museum and meeting place by the Saline Area Historical Society.

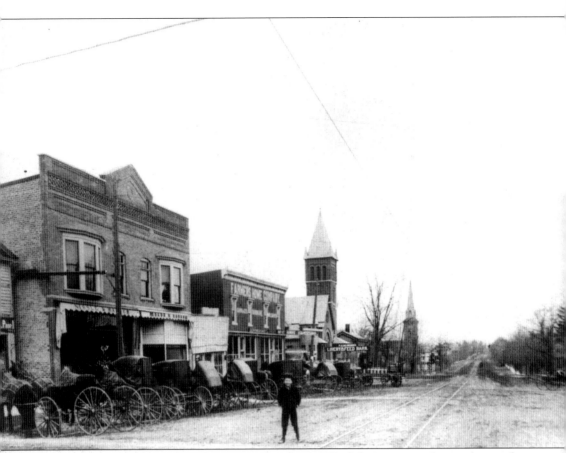

Here is the north side of Michigan Avenue after 1872. Saline supported several agriculture-related businesses such as the Farmer's Home Company and the Livery and Feed Barn. With all the buggies lined up, it looks like the village merchants were doing good business.

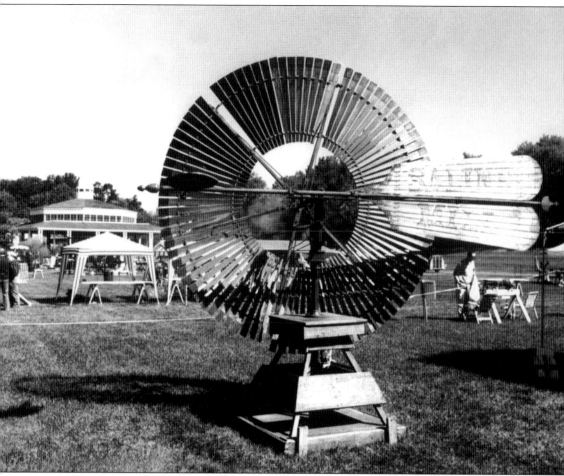

In 1875, J.C. Gross and Brothers bought a building on W. Chicago for their business, calling it Saline Standard Windmills. St. Paul United Church of Christ is now located there. The business that employed 12 men occupied one large manufacturing building, one pattern shop, and a blacksmith shop. In addition to pumps and windmills, they carried Fairbank scales and a variety of farm implements. This 1994 picture shows a Saline Wooden Solid Wheeler Windmill that was exhibited at Greenfield Village's "Power Pageant." It won the Engine Club's Oil Can Award. It was built in the 1880s by Saline Standard Windmills and given to the city by Arthur Weidmeyer of Saline Township.

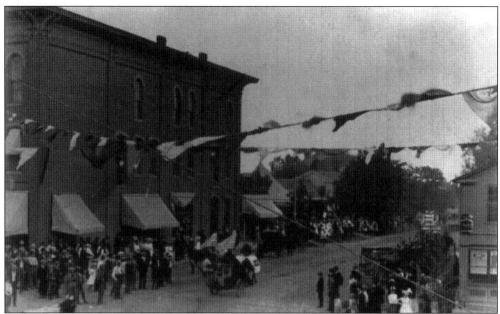

On July 4, 1876, Saline took part in the nation's centennial with a grand parade led by the village band with the G.A.R. and patriotic floats coming behind. A dance floor with a canopy of sapling trees was built across from the Presbyterian Church where a dance was held. The highlight of the celebration was the display of fireworks accompanied by music from the Fife and Drum Corps.

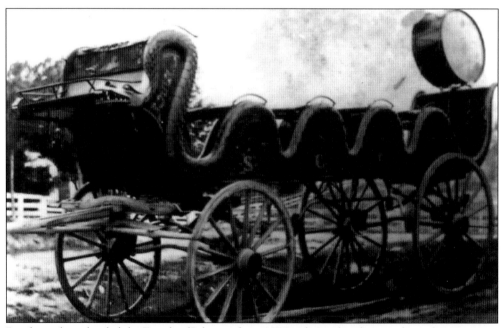

Band members that led the Fourth of July parade in 1876 rode in a bandwagon drawn by two teams of white horses. The bandwagon was built in the shape of a serpent with carved, gilded scales on its sides. The driver rode near the serpent's head and the band members rode on seats in the body and tail. The Schairer brothers who owned a wagon shop in Saline built this special bandwagon.

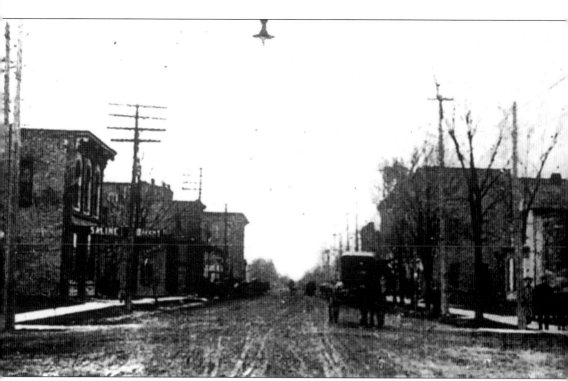

Here is Adrian Street looking north.

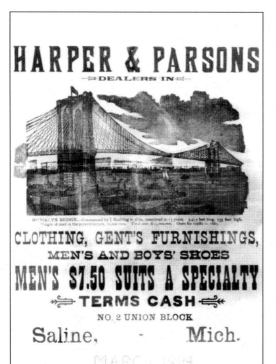

HARPER & PARSONS
—►DEALERS IN◄—

BROOKLYN BRIDGE.—Constructed by J. Roebling in 1870, completed in 13 years. 5,425 feet long, 135 feet high. Weight of steel in the superstructure, 20,000 tons. Total cost, $15,000,000. Open for traffic in 1883.

CLOTHING, GENT'S FURNISHINGS,
MEN'S AND BOYS' SHOES

MEN'S $7.50 SUITS A SPECIALTY
—►TERMS CASH◄—

NO. 2 UNION BLOCK

Saline, - Mich.

MARCH 1894

This Harper & Parsons advertisement is from March 1894. G.L. Parsons, co-owner, was the grandson of Cornelius Parsons, whose family owned Parson's Mill. In 1832 Cornelius started a men's clothing store on the northwest corner of W. Michigan Avenue and N. Ann Arbor Streets where G.L worked as a boy. Soon after the Harper & Parsons store was established, Mr. Harper went into another business. G.L. Parsons was a respected merchant for 64 years, and during the Depression gave away clothing to people who could not pay.

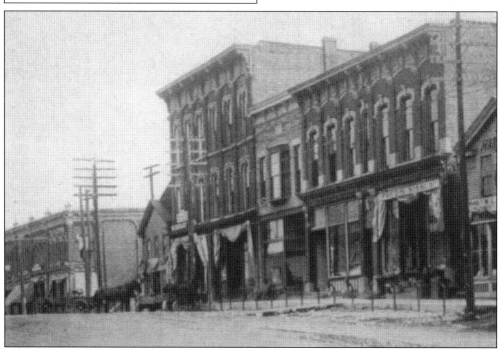

Pictured here is the Union Block around the turn of the nineteenth century. The G.L. Parsons store can be seen to the east (left) of the *Observer*. The *Saline Review*, the *Saline Oracle*, and the *Saline Standard* newspapers preceded the *Observer*, which was first published by the LeBaron Company in 1880.

A blacksmith shop was located at 98 N. Ann Arbor Street, the site now occupied by a bicycle shop.

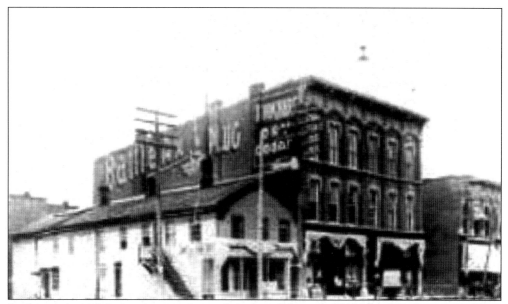

In this picture of the southwest corner of uptown Saline, the 1872 brick Italianate Burkhart building can be seen to the west (right) of the McKinnon building on the corner. A dry goods business was founded c.1871 under the name Aldrich and Burkhart. Around 1901 Mr. Burkhart's sons Fred and George continued the business under the name Burkhart Brothers. Their sister Katherine worked in the family store before her marriage to William Cody, a relative of Buffalo Bill Cody. Buffalo Bill visited Katherine and William on their farm west of town where St. Andrew Catholic Church now stands.

This portrait includes Fred Burkhart, J.J., and George Cook. In the 1930s George Burkhart became the sole owner of the Burkhart Store. George Cook ran the Saline Garage at 118 W. Michigan Avenue.

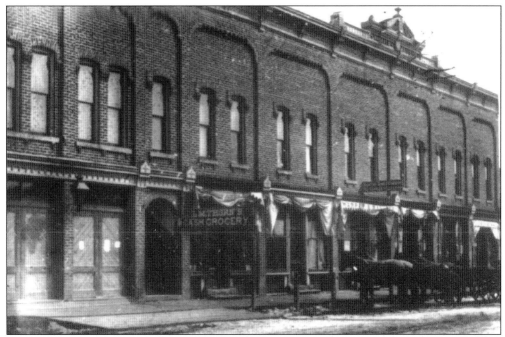

After a fire in 1881, the Wallace Block, located in the first block off E. Michigan Avenue on the east side of S. Ann Arbor Street, was rebuilt in brick in 1887. It was named for the builder Daniel Wallace, a stagecoach driver and landowner. On the left is the fire garage, and to the right of it L.M. Thorne's cash grocery and other businesses that comprised the ground level. The Opera House was on the second floor.

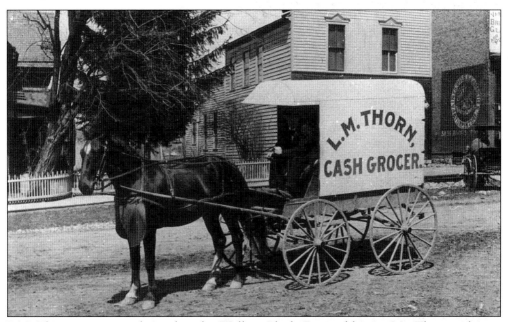

L.M. Thorn grocery was located in the Wallace Block. Pictured here is Mr. Thorn making a delivery in front of the *Observer* building before Michigan Avenue was paved in the 1920s. Notice the plank sidewalks.

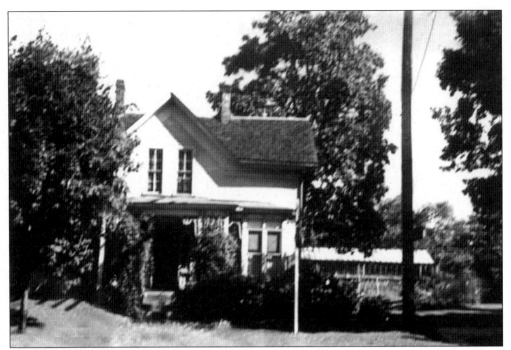

Minnie Ruckman operated her Saline greenhouse for more than half a century. The greenhouse was on the north side of W. Michigan Avenue. Her stepfather, Lucius S. Pierce, built the greenhouse on the lot with his residence. Pierce was also a local artist. Miss Ruckman assisted him in the care of the plants. After his death in 1914, she continued the business.

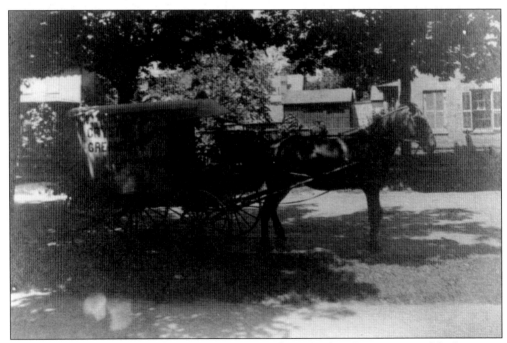

This delivery wagon belonged to A.G. Lawrence. The 1899 City Directory says Mr. Lawrence was in the "butter, eggs and general produce" business.

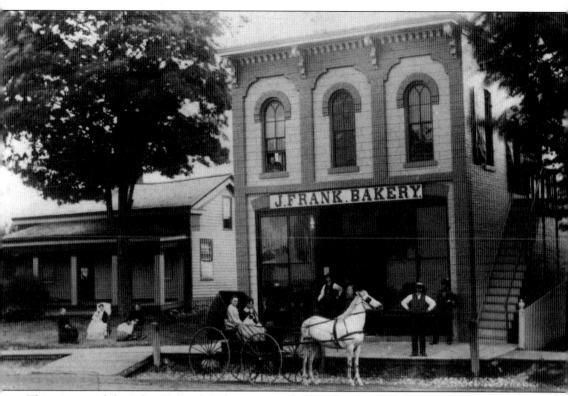

This picture of the John G. Frank Bakery was probably taken in the late nineteenth century. Mr. Frank built the structure, and according to ads in the 1878 *Saline Standard* newspaper, it housed a bakery and confectionary store "with a large stock of fresh candies on hand."

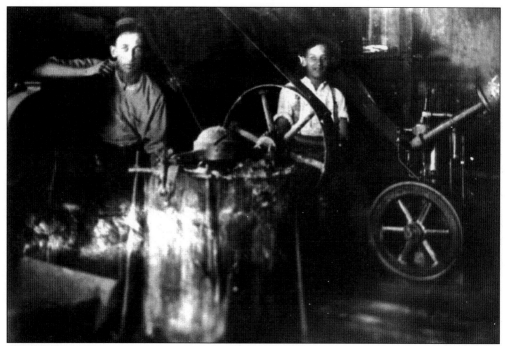

This *c.*1890 photo shows the ice cream-making machinery that was located at the Alber Bakery. A relative of John Frank, John Alber, later ran the business. Lilian Alber, the great granddaughter of John Frank, was also involved in the business. Later the building served as a hotel and a chicken hatchery, and currently as a law office.

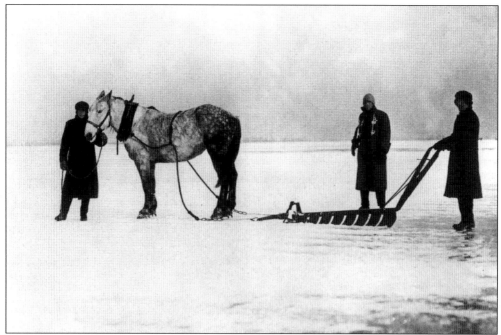

Ice-cutting with a horse-drawn cutter was a common winter chore. The ice may have been used in local households, or for making ice cream at Alber's Bakery.

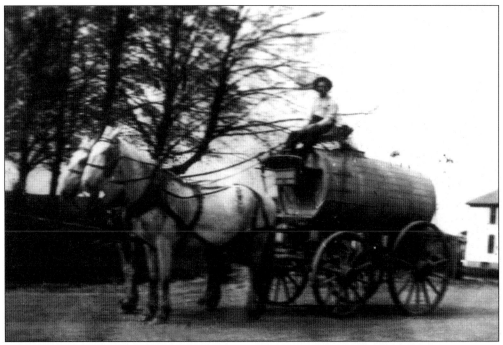

Prior to the paving of the Chicago Road in 1924, the city kept down dust on its streets with the help of a horse-drawn water wagon. The water was loaded at the Saline River.

To maintain dirt roads, townships used this road grading machinery. Farmers were given a tax credit in exchange for grading the roads with this equipment that was pulled by a team of horses.

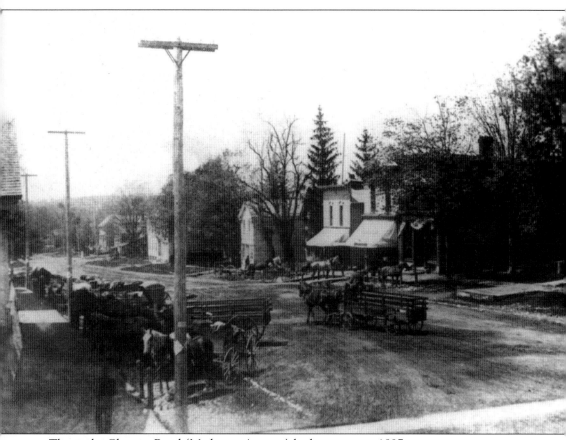

This is the Chicago Road (Michigan Avenue) looking west in 1897.

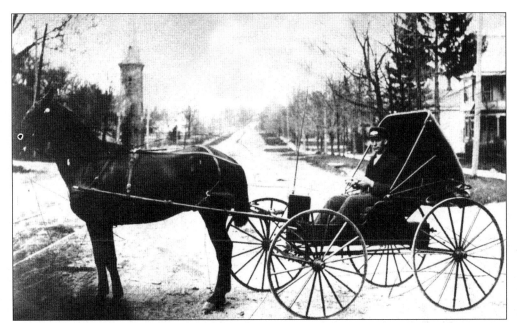

Albert Niethammer was the first rural postman in the Saline Post Office. From 1813 to 1843 postage was based on its destination. It cost 6¢ to carry a single sheet letter 30 miles. In 1850, three years after the introduction of postage stamps, a flat rate which did not depend upon the letter's destination was introduced. Rural Free Delivery began in 1896.

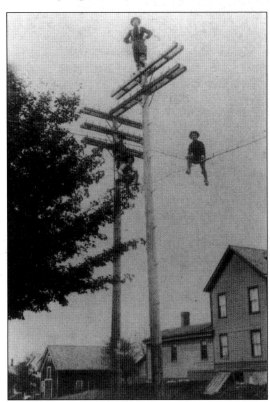

Workmen are stringing telephone lines on W. Henry and S. Ann Arbor Streets. In 1898 the first telephone lines were strung along existing telegraph poles.

The Detroit Edison Power Station was located at the northeast corner of US-12 and Harris Street, where the fire station now stands. The station provided power for the interurban car No. 7782, known as Old Maude. The trolley was powered by 600 watts of direct current that passed through the overhead wire and returned through the rails.

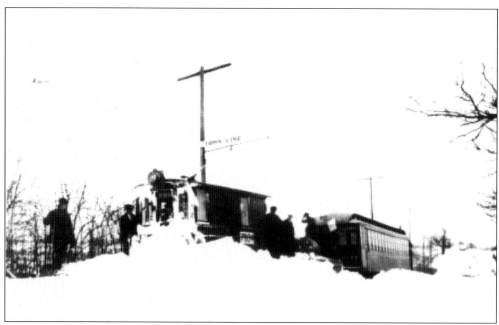

Old Maude transported people and goods along Michigan Avenue from 1899 to 1923. The electric interurban trolley operated on a branch of the line linking Detroit, Ann Arbor, and Jackson. Since Saline was a dead end stop from Ypsilanti, "Old Maude" made a turnaround near Hall Street for its return trip. Fares were a penny a mile.

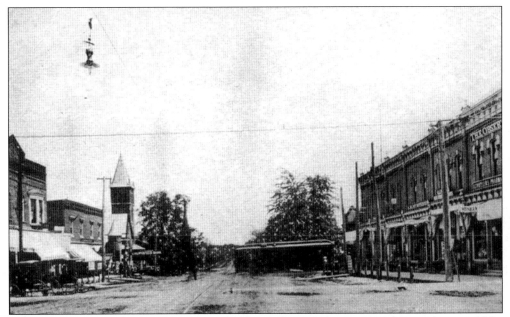

This photo of the downtown area shows Old Maude near the station where tickets could be purchased.

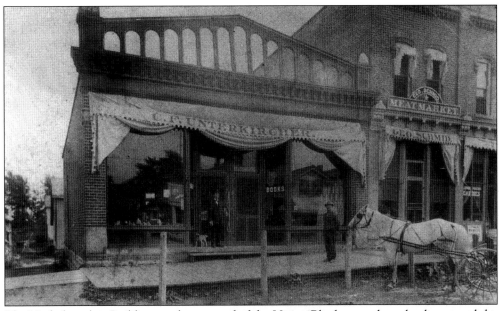

The Underkertcher Building, at the east end of the Union Block, served as a bookstore and the Old Maude Station. Next to Underkertcher's is George Schmid's meat market. In 1925, Ben Uphaus bought the building, which over the years housed a confectionary store and Uphaus Electric. The interesting cornice is no longer part of the façade.

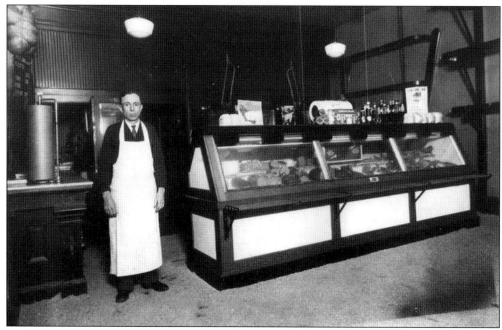

George Lindenschmidt built this store in the late 1800s. He opened it as a meat market with Mr. Schwaim as his partner. Lindenschmidt later bought him out. The next owner was George Schmid who emigrated from Germany and brought formulas for curing and seasoning meats, for which he was famous. By 1940, three generations of Schmids had run the business.

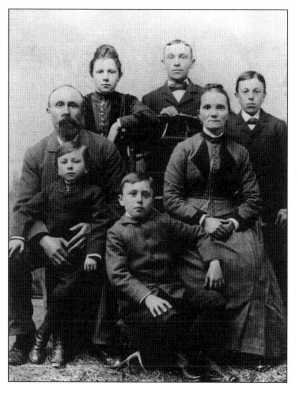

Here is the George Schmid family.

Six

INTO THE
TWENTIETH CENTURY

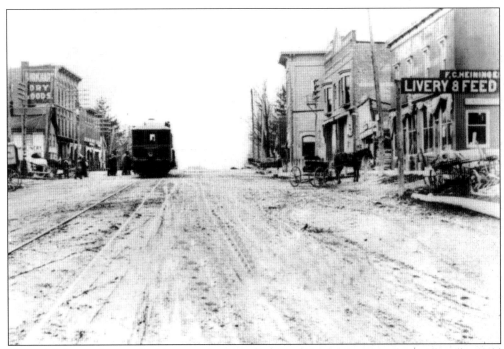

This is Michigan Avenue looking west in the early twentieth century. Travelers are boarding Old Maude, off to parts unknown. From settlement times, Saline had grown to a bustling village with several businesses, the interurban, the railroad, several churches, good schools, and a strong connection to agriculture. Amenities such as water service, the Saline Library Association, a weekly newspaper, telephone service, and electric lighting soon became part of everyday living.

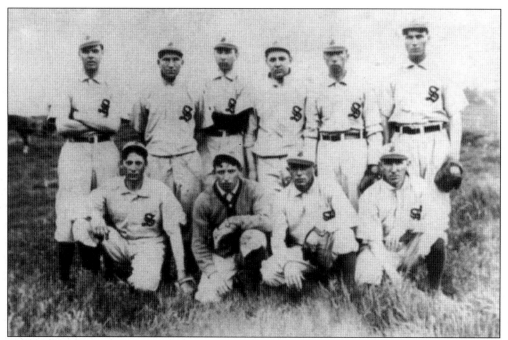

This photo of the Saline semi-pro baseball team was taken in 1908. Pictured from left to right are the following: (back row) Prof. Walling, Charles Reeves, unknown person, Fred Burkhart, Ed Barnard, and Art Armbruster; (front row) Oscar Wheeler, J. Rogers, Bert Gillen, and Henry Schroen.

Minnie Jones, another Saline businesswoman, had a home and coal yard located on W. McKay Street. Her husband, Benjamin, had been in the coal business in the late nineteenth century. Pictured here are Merilla Allen, Minnie Jones, and Lucinda Cobb.

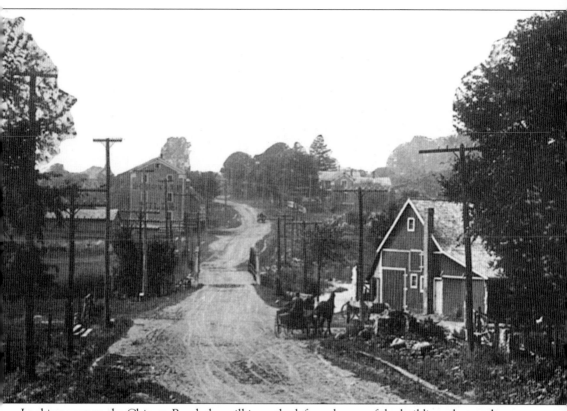

Looking west on the Chicago Road, the mill is on the left, and some of the buildings that made up Barnegat are on the right. In 1912, when this picture was taken, Orris Klein owned the gristmill.

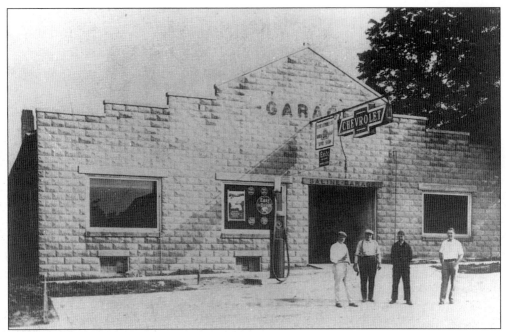

The Saline Garage stood where the parking lot next to St. Paul's Church is now located. George V. Cook established The Saline Garage around 1912. His son, Walter, later ran it until his death in 1940.

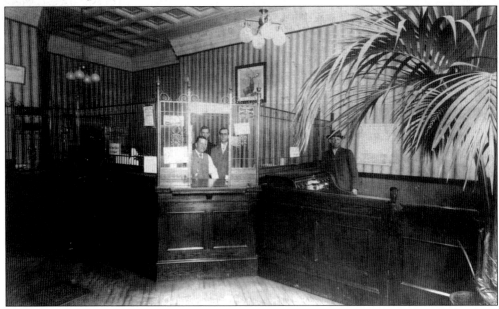

The Saline Savings Bank was built in 1917 on the southwest corner of Michigan Avenue and S. Ann Arbor Street where the McKinnon building once stood beside the Burkhart Building. Pictured here are George Burkhart, president, G. R. Lehman, cashier, E.D. Skinner, assistant cashier, and George J. Feldkamp, director. The Saline Savings Bank was chartered on May 23, 1908, and first operated in a building at 109 W. Michigan Avenue. In the early years, some bank documents were printed in both English and German.

This World War I convoy is passing the corner of Willow Road and US-12 heading east in Saline Township *c.* 1918.

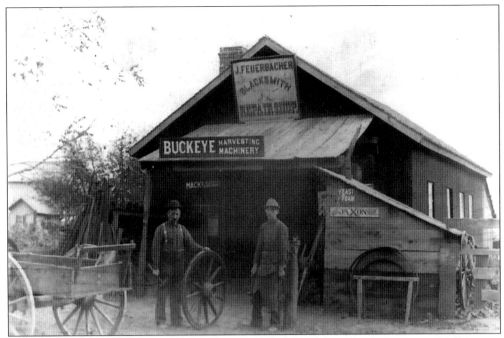

The Feuerbacher Blacksmith Shop was located near the depot where the auto parts business now stands at 406 N. Ann Arbor Street. Pictured is John Feuerbacher in front of his blacksmith shop c. 1930. Feuerbacher also dealt in scrap iron that was sold and loaded onto railroad cars directly south of the business.

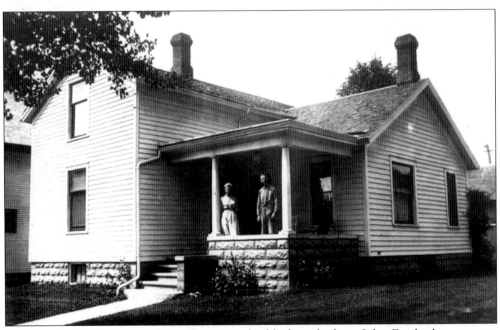

The Feuerbacher home was located next to the blacksmith shop. John Feurbacker came to Saline from Nagold, Germany in 1870 at age 18.

This camel back bridge once spanned the Saline River near the dam on US-12.

These two women appear to be enjoying a summer day on the Hartman Road Bridge near the Saline Mill in York Township.

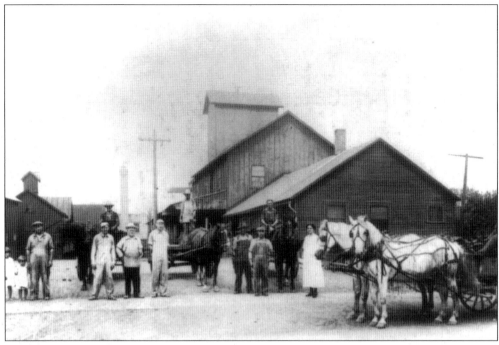

The Saline Mercantile on N. Ann Arbor Street was in business from 1917 to 1973. They operated a grain elevator, lumber, paint, and hardware business near the railroad tracks. This is the Grain Elevator division that ground feed, sold farm products, and bought grain for shipment. The area was once a stockyard for cattle and pigs that were brought to Saline by rail for slaughter.

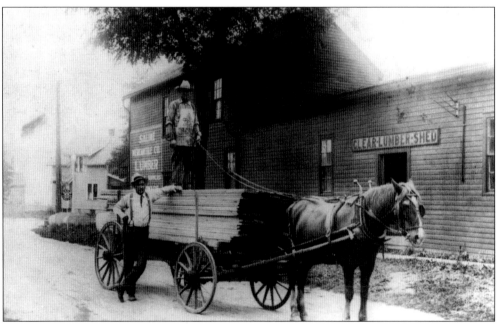

Pictured here is the Lumber & Hardware Division of Saline Mercantile showing the W. Bennett Street side of the business.

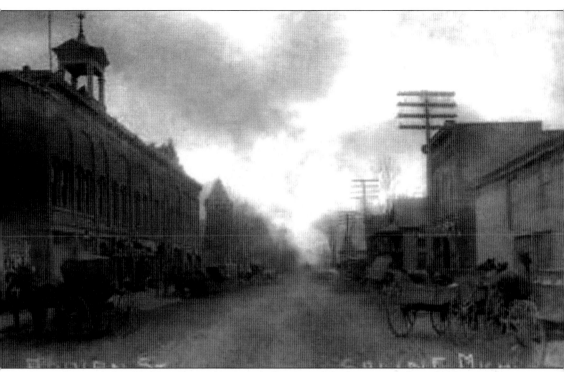

Here is the east side of Adrian Street (S. Ann Arbor Street) looking south from the four corners (intersection of Ann Arbor and Michigan Avenue) in 1906. In this picture, the Saline Co-operative Company and a grocery store are on the ground level of the Wallace Block. The Opera House, on the second floor, had a large room that was used for many functions such as roller-skating, town meetings, and for high school graduations. A quote by Lula Fairbanks in the June 6, 1906 *Saline Observer* helps one to visualize graduation day, "June 6, 1906 was a very special day in the old Opera House. Four 'sweet girl graduates' played a double duet for the first time in Saline's history on two pianos. They had been hauled over from Ann Arbor in a big lumber wagon by two shaggy black horses and there was much excitement over the program. The place was packed, the long stairs filled, and a big crowd stood along the sidewalk across the street to hear *Poet and Peasant Overture*." In the 1940s, Meredith Bixby used the space for his studio and would preview his marionette shows here.

Russ Payuer, his Model T truck carrying a load of schoolchildren, participates in a parade in uptown Saline.

A Saline Fair was held at Union School on Henne Field *c.* 1948. The depot storage barn can be seen in the background.

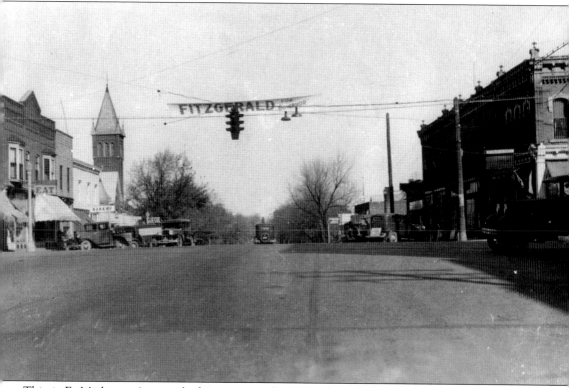

This is E. Michigan Avenue looking east in the 1930s. Notice that the road is paved, and Saline's first traffic light appears above the four corners.

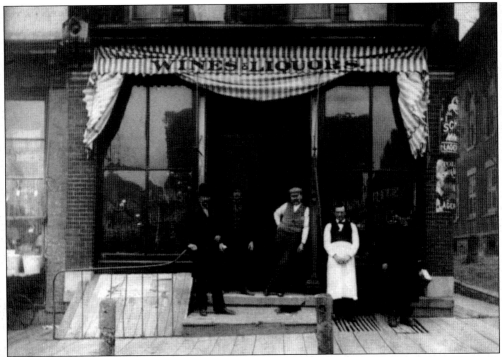

Here is the John Fritz Store on W. Michigan Avenue c. 1930. It was located alongside the Harmon House on the right and *Saline Reporter* on the left. The Fritz home was on E. Henry Street.

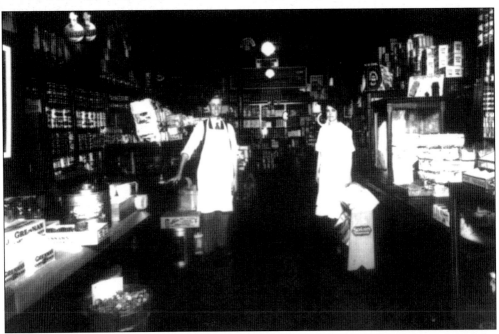

Cook's Grocery store was on the north side of E. Michigan Avenue, three stores east of the four corners. Here we get a glimpse of the interior of the store showing Mr. Cook with employee, Mamie Schroder.

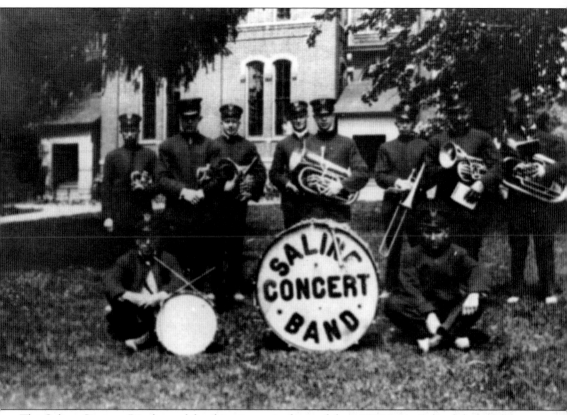

The Saline Concert Band posed for this picture in front of the 1868 Union School during the early twentieth century.

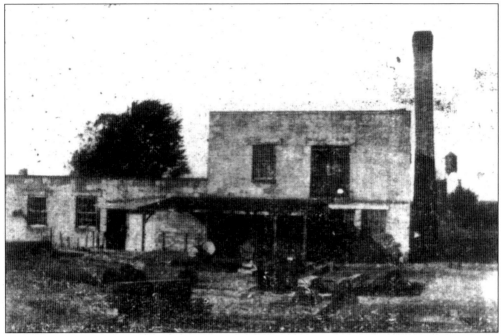

The C.F. Bracey Handle Factory operated in the 1930s and 1940s on W. Bennett Street. The factory produced hammers, handles, baseball bats (including the Louisville Slugger), and other wood products.

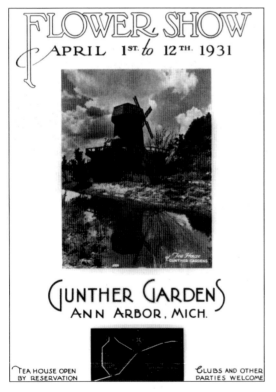

Gunther Gardens was a landscaping business located on Saline-Ann Arbor Road, about one mile north of Saline. Ed Gunther owned the business in the 1920s and 1930s. Aided by his assistant, Bill Dusterbeck, perennials, shrubs, dogwoods, cedars, and pines were planted along Saline-Ann Arbor Road. A full-scale decorative windmill-teahouse was built on the 40 acres to entertain potential customers. Gunther Gardens went out of business during the Depression.

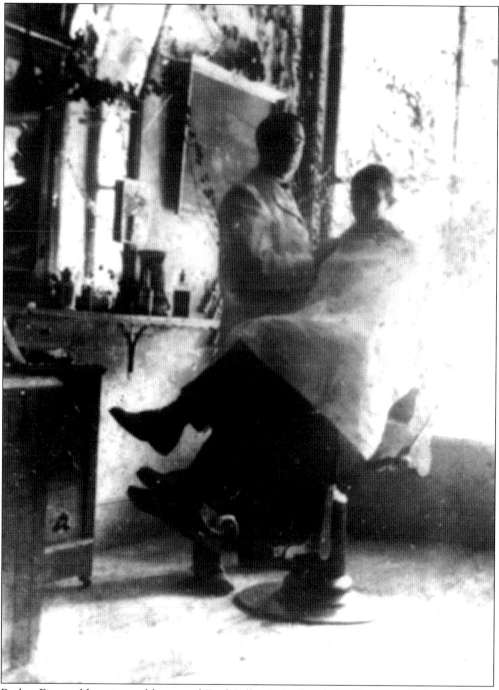

Barber Fitzgerald is pictured here, and Fred Sellen is in the chair. Chauncey F. Fitzgerald was employed by H.E. Hormsby.

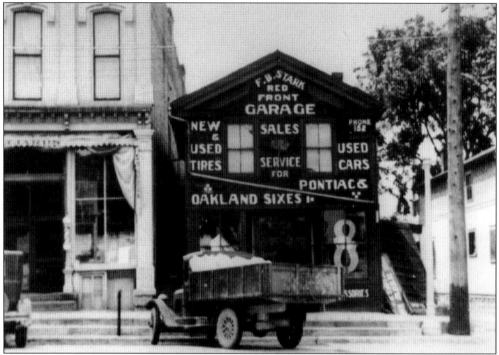

F.B. Stark's Red Front Garage provided sales and service. It was the last of the commercial wood buildings on W. Michigan Avenue. The photo was taken around 1927.

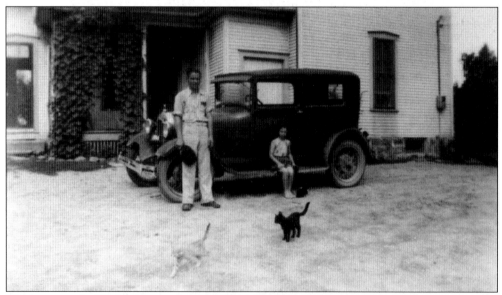

This picture of a Model A was taken in 1937. The *Saline Observer* stated in January 1943 that "Gasoline is shooting skyward as a result of the heavy demand from auto owners and before long the price is likely to reach 30¢ a gallon."

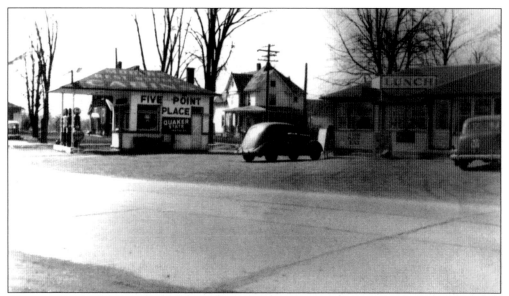

Chris and Lydia Volz owned Volz's White Star Service at 401 E. Michigan Avenue. They purchased the gas station c. 1930 from Carl Kluwe, who built the structure in 1929. White Star Gasoline was the precursor to Mobilgas. Known as Five Point Place, there was also a restaurant, as well as tourist cabins, on the property. The service station was renovated in 1974 to be used as a Chicken Take-Out.

Tourist cabins, built in 1933, were located behind Five Point Place. The cabins rented for $5 per night for two people. Showers and toilets were attached to the rear of the restaurant.

Hull's Grocery and Gas Station, located on N. Ann Arbor Street, was in business during the 1940s and 1950s.

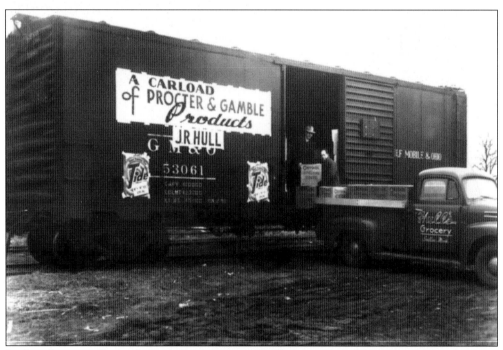

In this photo, produce is being unloaded into a Hull's Grocery truck from a rail car.

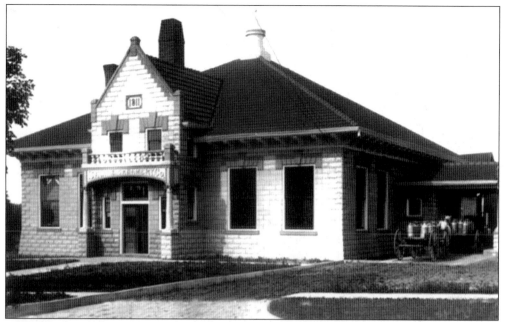

When this post card was printed in 1910, Ed Hauser owned the Saline Creamery.

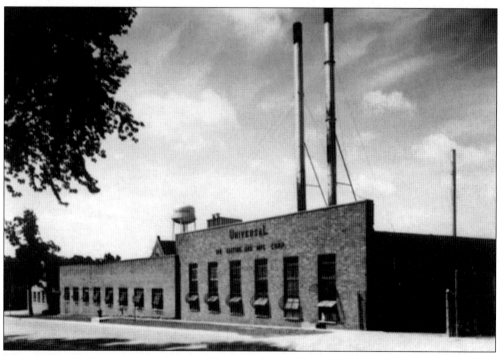

The April 13, 1944 *Saline Observer* announced that the Universal Die Casting and Manufacturing Company purchased the Saline Creamery building from the Citizens Bank. A brick industrial building was built around the Saline Creamery. The Creamery roof is still visible by standing across Monroe Street. Employing 75 people, the company designed their own machines to make small die-castings.

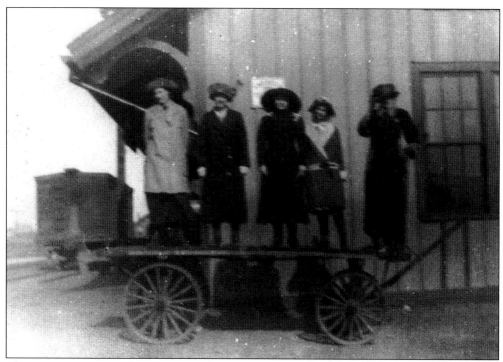

These women appear to be posing for a picture at the depot. Resplendent in fashionable clothes of the time, one wonders if they are off on a trip, or have just arrived.

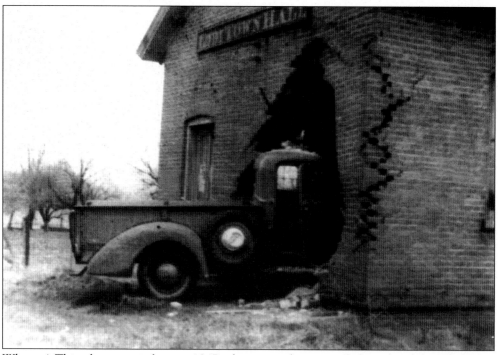

Whoops! This photo was taken in 1947 when a truck impacted the side of the 1869 Lodi Township Hall at Zeeb and Pleasant Lake Roads.

Two Experiments in Agriculture

Saline Valley Farms and Ford Village Industries

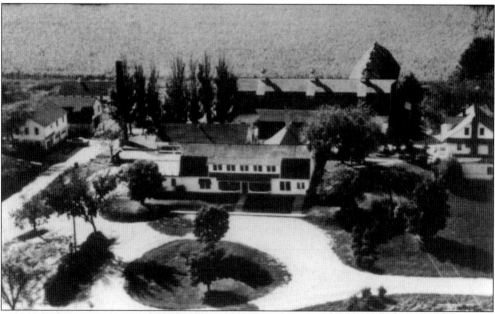

An aerial view of Saline Valley Farms shows one of two non-traditional (at least for Saline) agricultural projects that existed during the 1930s and 1940s. Formed in the post-Depression years, Saline Valley Farms and Ford Village Industries gave jobs and hope to many area residents. In the 1930s, millionaire Harold Gray along with Harold Vaughn built Saline Valley Farms, a cooperative farm venture. In March 1932, 600 acres of land with a farmhouse and barn were purchased by Gray and later expanded with more homes and buildings. The project lasted for approximately 20 years and fell on hard times after World War II when area jobs were more plentiful.

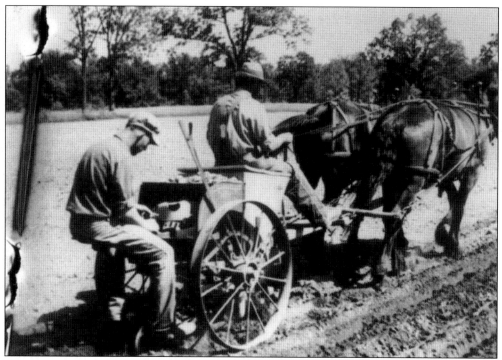

Here two workers are planting potatoes at Saline Valley Farms with horse-drawn machinery.

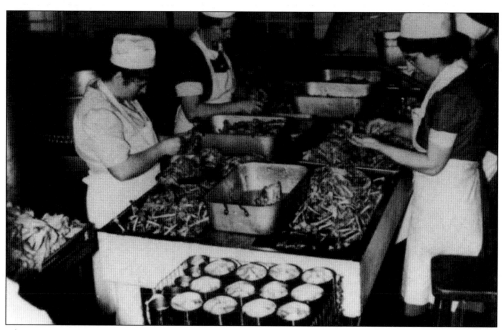

The cooperative farm grew fruit and vegetables for their own use and for market. Here vegetables are prepared for canning. The co-op had its own cannery.

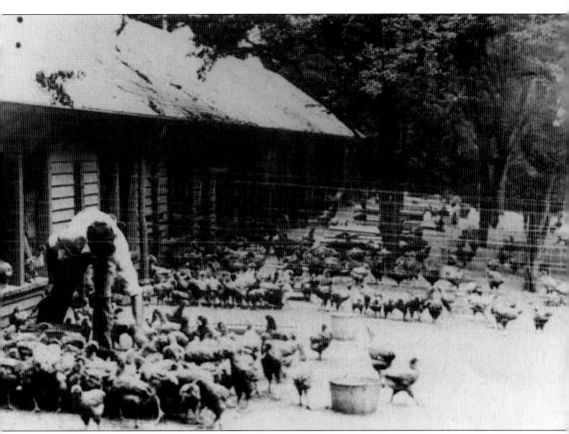

Shown here feeding chickens at Saline Valley Farms is Art Hagen. Chickens were raised for both meat and eggs.

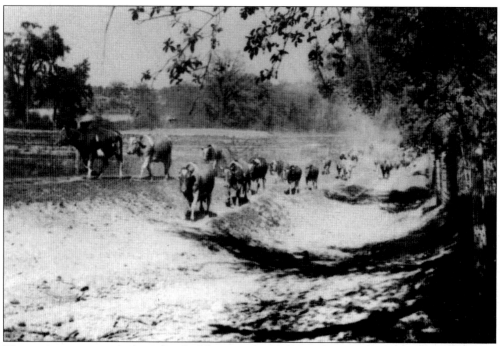

The cooperative raised a large herd of dairy cattle. They are shown here returning to the barn.

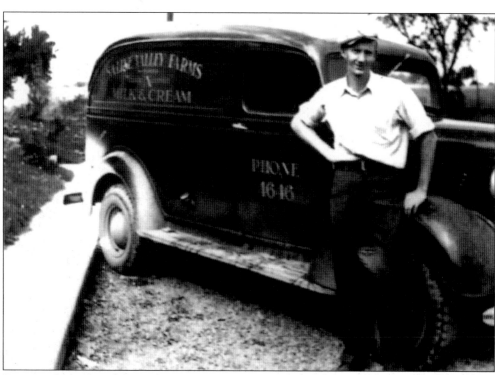

Dairy products were delivered to outlying areas such as Birmingham, Berkley, Highland Park, Royal Oak, Ann Arbor, and of course, to Saline.

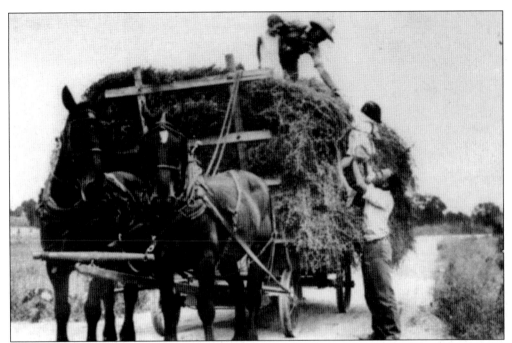

One of the farm children gets lifted to the top of the hay wagon at Saline Valley Farms.

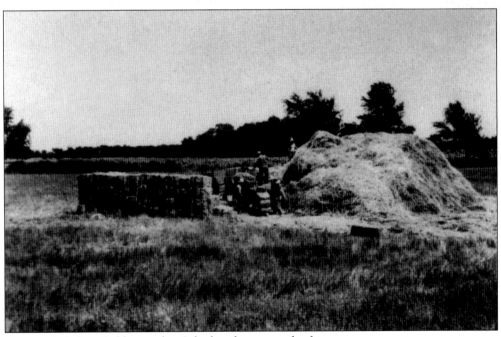

Hay was baled, probably on a hot July day, for use on the farm.

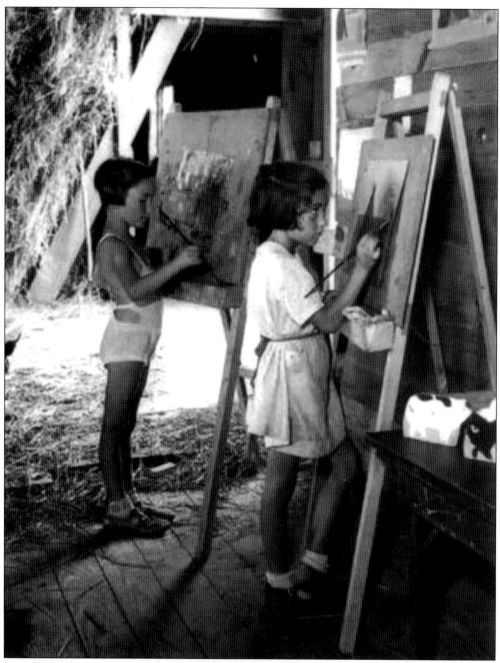

Here are two young artists at Saline Valley Farms.

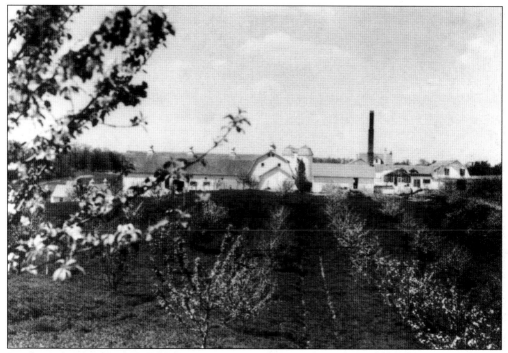

Peaches, cherries, apples, and pears were grown in the extensive orchards.

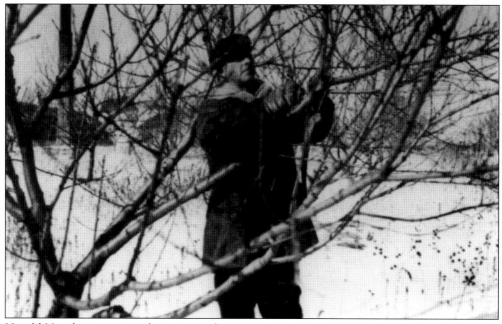

Harold Vaughn is pruning fruit trees in late winter.

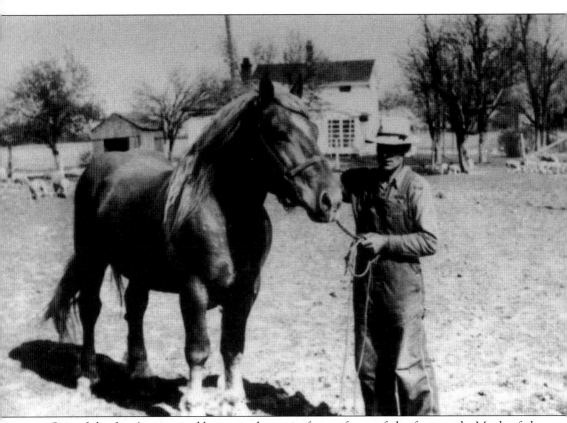

One of the farm's prize workhorses is shown in front of one of the farmsteads. Much of the farm's labor was done with the aid of "horsepower."

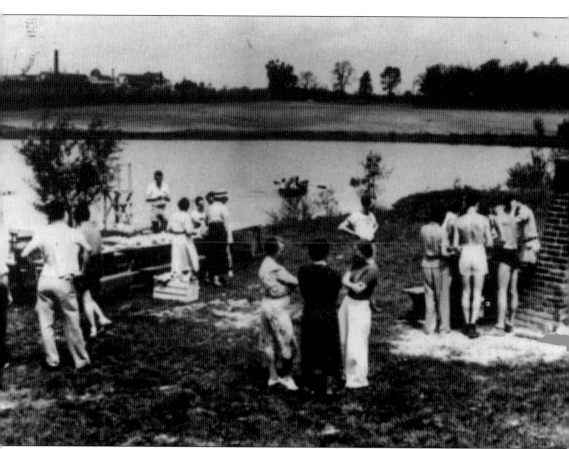

In addition to hard work, families took time to socialize. Here residents are shown enjoying the man-made lake and picnic grounds on the property.

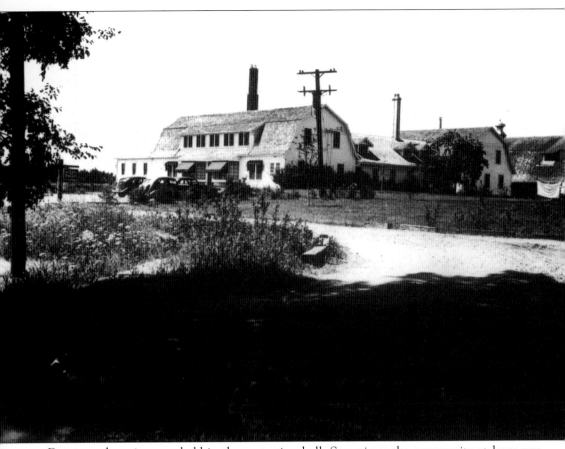

Dances and parties were held in the recreation hall. Sometimes the community at large was invited, apparently to dispel socialist rumors.

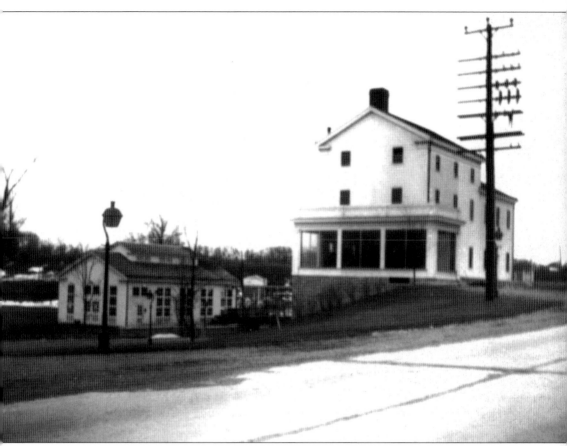

A second agricultural experiment was Ford's Village Industries, established on the site of the old Schuyler Mill. Over the years, the 1845 Schuyler Mill changed hands and was renovated several times. Due to its location near farmland and its source of waterpower for processing, Henry Ford purchased it in the 1930s to become part of his Village Industries. The vernacular style mill was moved onto a new foundation, the water wheel removed, and two rooms, one with a generator, were added. Ford's own style of Greek Revival exterior trim was added. The Village Industries' experiment was a personal project of Henry Ford, one in which he attempted to provide an environment wherein agriculture and industry could coexist. On the property he built an extractor plant for soybeans and a pump house. A new dam was built along with a millpond and a new millrace. Soybeans, grown locally, were processed in the facility to be used for plastics and animal food. During World War II, the plant was put into wartime production. Ford sold the business in 1946.

Henry Ford tests the durability of a car using plastic made from soy.

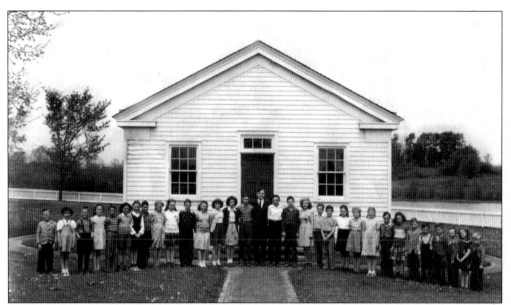

In 1943, the Hoyt-Sumner School was moved from Macon Road and situated across from the Schuyler Mill to become part of Ford's Village Industries project. Though built to look like the old school, much of what was to become the Hoyt-Ford School was the product of new construction. Two windows were added to either side of the front door, and the belfry was not replaced. Due to Henry Ford's poor health, the Ford Motor Company sold the school along with the mill in 1946. In 1947, the property was purchased by Mr. and Mrs. Bruce Parsons and remodeled as a residence.

Schools were part of the Ford Village Industries project. Pictured here is the 1945 graduation class of the Hoyt-Ford School. The kindergarten through eighth grade school provided a broad curriculum to both children of Ford employees and other area children. Manners, respect, and cleanliness were taught. Free dental and health care were also provided.

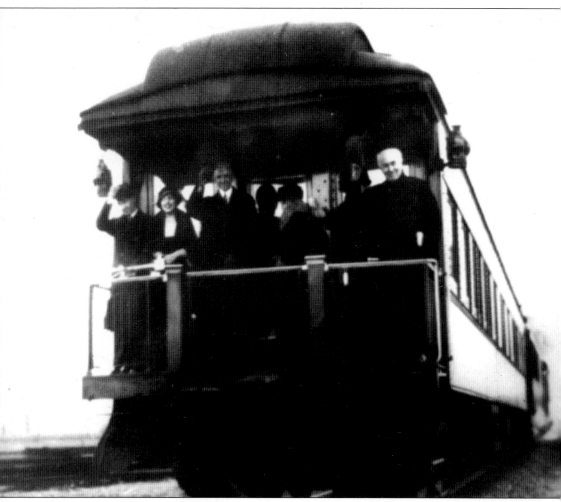

Henry Ford's Village Industries project unquestionably made an impact on Saline in the 1930s and 1940s. In the second half of the twentieth century, Saline had another opportunity to be associated with Ford history. Pictured here are Harvey Firestone, Henry Ford, and Thomas Edison in Ford's private car, the Fairlane, some time in the first part of the twentieth century. This railcar was stored in Saline for security purposes from 1995–1996. In 1998, it found a home at Greenfield Village.